pictureSHOW

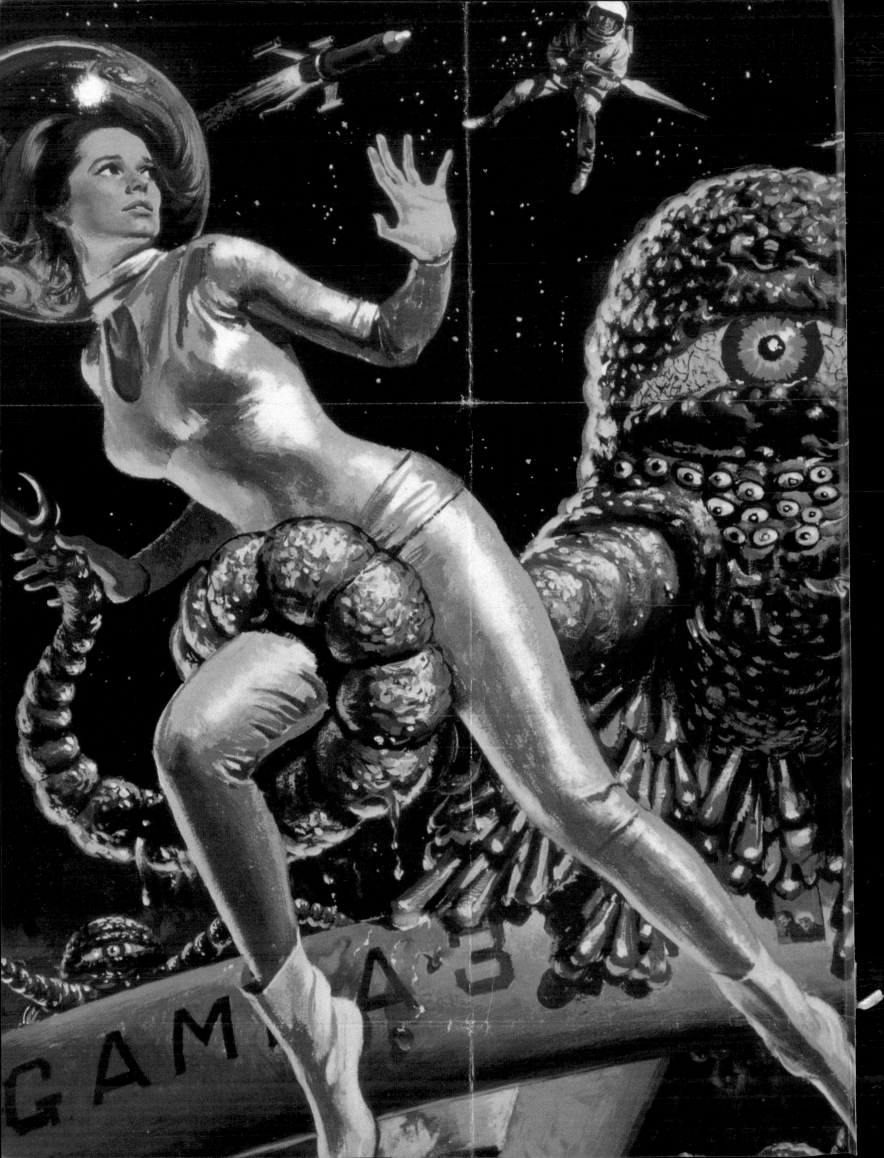

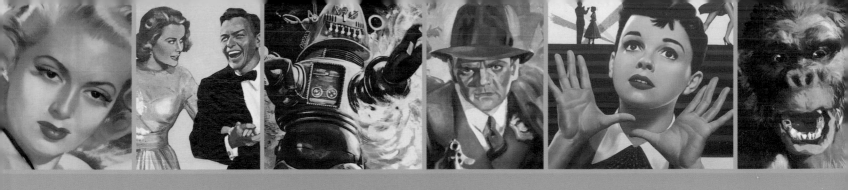

pictureSHOW

CLASSIC MOVIE POSTERS
FROM THE

ARCHIVES

FOREWORD BY
ROBERT OSBORNE

TEXT BY
DIANNA EDWARDS

CHRONICLE BOOKS
SAN FRANCISCO

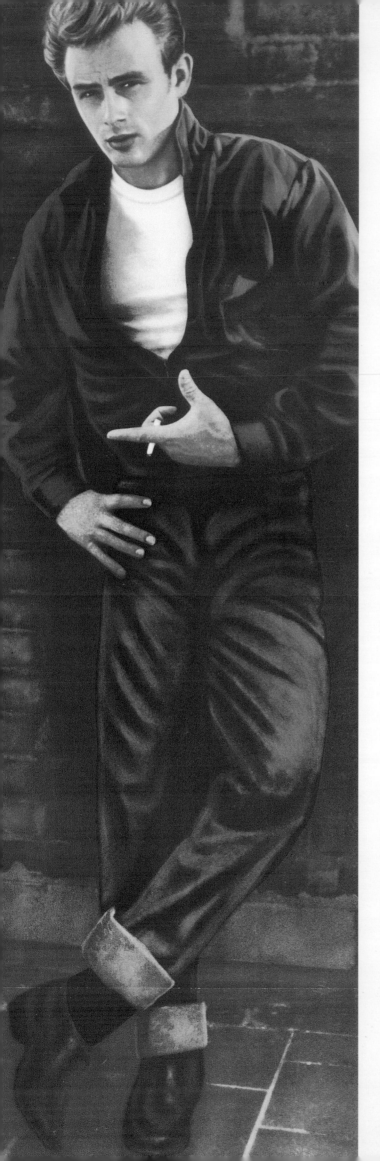

Library of Congress Cataloging-in-Publication Data available.
ISBN 0-8118-4154-5
Manufactured in China.
Designed by Mclanie Paykos Design.

Distributed in Canada by Raincoast Books
9050 Shaughnessy Street
Vancouver, British Columbia V6P 6E5

10 9 8 7 6 5 4 3 2 1

Chronicle Books LLC
85 Second Street
San Francisco, California 94105
www.chroniclebooks.com

COVER: *Gigi*, 1958, MGM

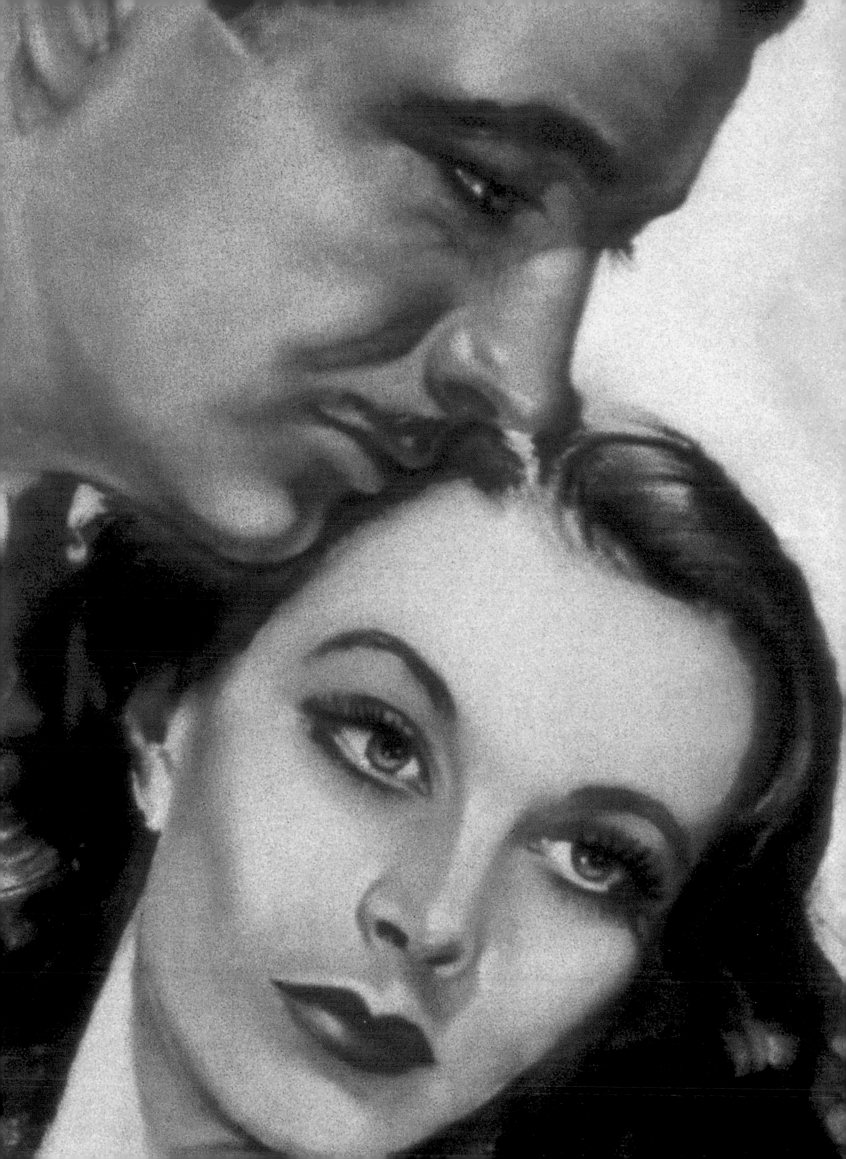

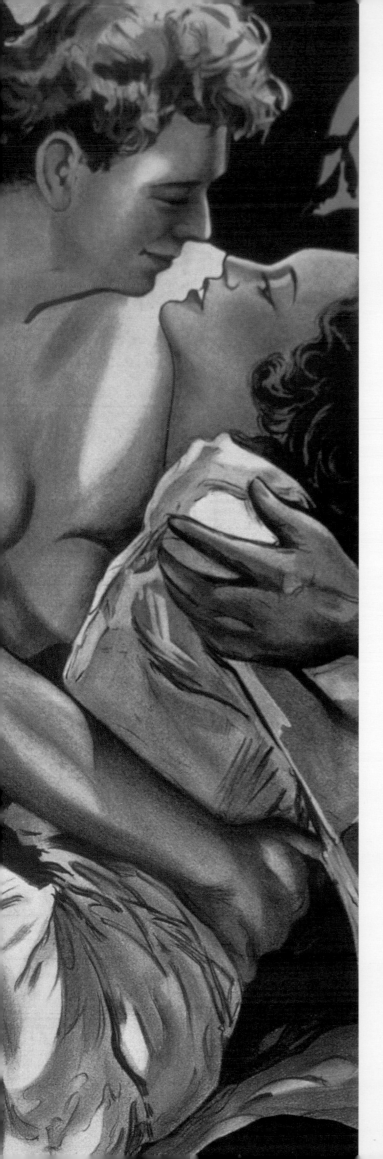

DEDICATION

To Ted Turner
Without his foresight and commitment to film restoration and preservation, there would be no Turner Classic Movies.

ACKNOWLEDGMENTS

As in all great picture shows, this book reflects the collaborative efforts of many. Editorial and Design: Brooks Branch (Creative Branding Group); Dianna Edwards and Hadley Higginson (Words and Ideas); Carrie Beers, Katherine Evans, Les Howell, and Dennis Millay (TCM); Melanie Paykos, Greg Chinn, Adam Ford, and Kaz Brecher (Melanie Paykos Design). Research and Production: Woolsey Ackerman, Carrie Beers, and Eric Weber (TCM); David Graveen and Annette Danies (Anvil Archive); Anne Murdoch.

SPECIAL THANKS

To Tom Karsch, EVP and general manager of TCM, Robert Osborne, TCM's on-air host, and our gifted colleagues at TCM for their valuable insight and support. You inspire us every day in our mission to keep classic movies alive and relevant for a whole new generation.

CONTENTS

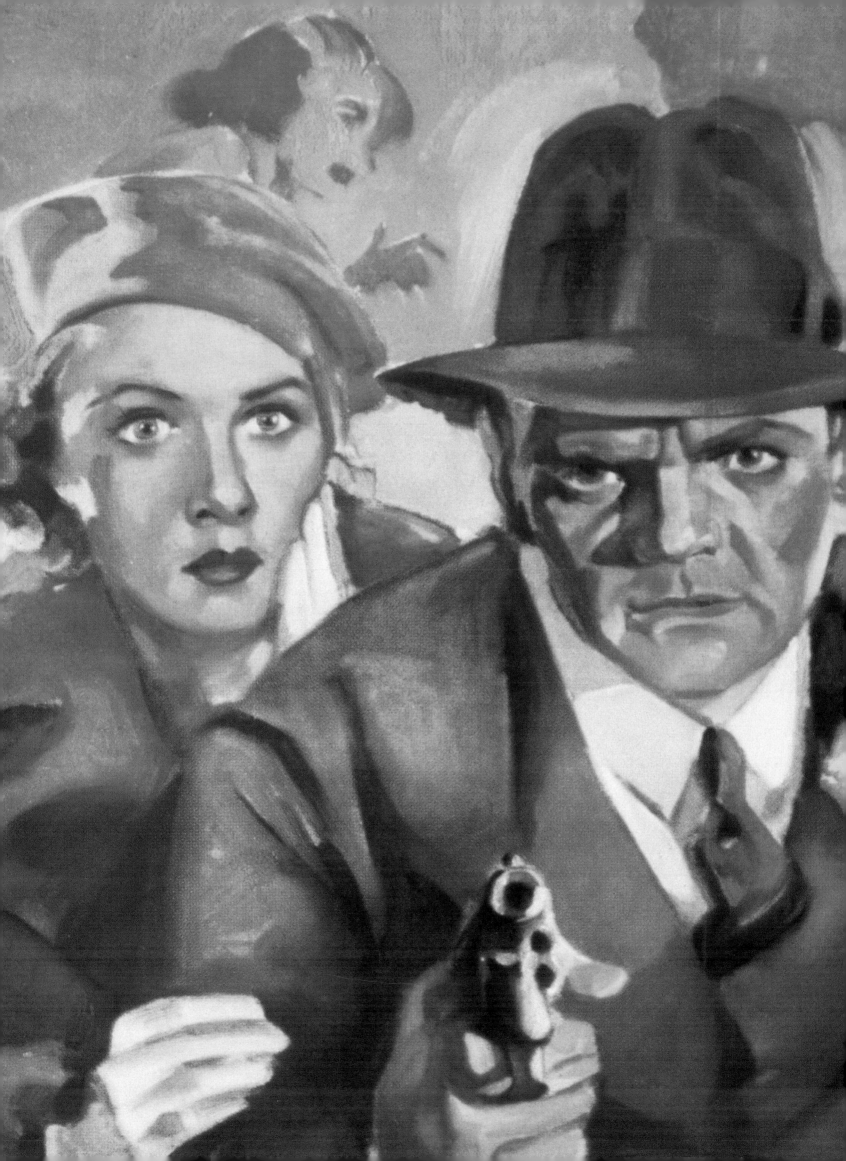

Foreword

I have to admit it: as much as I love movies, I may love movie posters even more. They were designed to lure thousands like me into plunking down coins at the box office of the local Bijou but, far beyond that, they have also given me hours of gawking pleasure. No comic book I ever read as a kid gave me as much bliss as staring at an advertisment of Errol Flynn, bow in hand, about to zing an arrow into an enemy, in *The Adventures of Robin Hood*. Nor could I resist the poster for 1947's *Nora Prentiss* with a bare-shouldered, half-smiling Ann Sheridan, under a headline that asked, "Would you keep your mouth shut if you were Nora Prentiss?" (I had to know what it was that Nora should, or shouldn't, be talking about.) One of the added delights of this book is the chance to see how Hollywood sold its wares at a time when the most important thing a movie poster could do was, in one quick glance, let a prospective ticket buyer know (a) the title of said film, (b) who's in it, and (c) its genre, be it a comedy, a musical, a western, or film noir drama. Through the selected posters in this book you'll find it fascinating to watch the progress of certain careers, illustrious or otherwise. In the poster for 1935's *Bordertown*, for example, you'll see that Bette Davis's name is listed below the film's star Paul Muni, and below the title itself, but in *Dark Victory*, released four years later, Bette is the whole enchilada, the film sold solely on the basis that she is in it. (Meanwhile, the billing of fellow *Dark Victory* cast members Humphrey Bogart and Ronald Reagan is so miniscule one almost needs a magnifying glass to find them, yet each gent later became a prominent selling tool for such films such as Bogie's *The Maltese Falcon* and Reagan's *International Squadron*.) I hope you find it a hoot to see ads with Judy Garland, Robert Mitchum, Jimmy Stewart, Kirk Douglas, and other greats listed far down in the credits before their names took on a lure of their own. Also notice the vagaries of billing in films such as *House of Wax*, *Them!*, and *The Thing from Another World*, in which the cast members are either ignored altogether or given short shrift. Do enjoy this trip into Hollywood's golden past, then check out Turner Classic Movies where, among other treats, you'll be able to find out exactly what it is that Nora Prentiss should, or shouldn't, have been yakking about.

Robert O.

—ROBERT OSBORNE,
Primetime host, Turner Classic Movies

Introduction

THEY WERE EXPECTED TO LIVE FOR WEEKS but they've lasted for decades. Some are haunting and beautiful—others are pure camp. Whatever their creators' original intention, one thing is certain. Movie posters aren't just posters. They are small-scale masterpieces of strategic communication with every element from typography to color planned to do one thing: lure audiences into theaters. ✳ The reality is, posters were never meant to have a life span outside the run of a film. They were just *advertising*—one element in a kit of sales tools cranked out at lightning speed to hawk films that could open and close in a matter of days. At the height of production in the late thirties, some 350 new films were released each year, so theaters were deluged with posters that were used once and banished to the basement—or worse. Precisely because they were created to be ephemeral, many posters were simply lost forever. (As were, by the way, about half of the films made before 1950.) Since the late sixties, vintage movie posters have held sway over increasing numbers of movie fans and collectors. And even though they aren't what most people would call "serious" art, movie posters now command serious prices at auction. ✳ In his wildest dreams, even the most prescient Hollywood mogul never envisioned his movies surviving this long—much less that a poster for even a forgettable film could be worth thousands.

IN THE DAYS OF SILENT FILMS AND EARLY TALKIES, posters, hand-illustrated and hand-lettered, were the most practical way to trumpet the arrival of a new film. * In practice, they worked the same way carnival handbills did—and at similar decibel levels. A poster's job was to paint a film so vividly it would be irresistible at a glance, and just as with today's advertising, impact was more important than accuracy. * A movie campaign was a promotional blitzkrieg of sound and fury with a clear objective—selling tickets—and a simple strategy—creating buzz. There were many weapons in the movie studio's arsenal, from syrupy stories planted in fan magazines to wacky promotional stunts and impassioned trailers. But movie posters manned the front lines at the ticket window. * Exhibitors ordered posters, lobby cards, and other sales trinkets from elaborate "pressbooks." Single sheet posters for display cases were (and still are, in printing parlance) called "one-sheets," but there were also half-sheets, three-sheets, six- and twenty-four-sheet posters for billboards, all created by the studio's publicity department. Under the careful eye of an advertising or publicity director, promising upstarts and top commercial artists painted poster imagery from as little as a few photographs or with luck, a script.

IN HOLLYWOOD'S GOLDEN AGE, each of the major studios had their own roster of stars and distinctive style of filmmaking and their posters followed suit. ✳ Before the moralistic Hays Code was enforced in 1934, there was ample creative license. (Note the barely clad dancer from *Footlight Parade* on page 60.) But afterwards, this code of ethics purporting to protect audiences from "crime, wrongdoing, evil, or sin," dictated, among obvious trespasses such as nudity, that kissing be done upright. That way, no one would think the couple might be . . . reclining. ✳ Of the three major studios featured in this book (MGM, Warner Bros., and RKO), MGM's posters and films were considered the gold standard. MGM often enticed the best illustrators in New York to paint worshipful portraits of its stars, which were presented in lush graphic treatments. ✳ If MGM was about glitter, Warner Bros. was about grit. Frugal Warner Bros. actually vetted its poster campaigns with advertising experts. The result was stylish two-color designs dominated by photography, a mid-thirties Gallup poll recommendation that also cut costs. ✳ RKO may have been a small studio, but it was still a powerhouse, packing a wallop with brash, pugnacious films and gutsy posters with crowded designs and bold color palettes.

❧❧❧

BEFORE THE SHOW BEGINS, A CAVEAT. *Picture Show* is not intended as a definitive work on movie posters. It is an introduction to classic movies presented through the prism of their posters, done with the respectful irreverence you'd expect from Turner Classic Movies. ✳ Rather than curating strictly by genres, we've focused on character types and themes that bring those genres to life. "Bad

Girls," for example, appear in westerns as well as film noir, but wherever one shows up, she's likely to be wearing something strapless. ∗ Posters were culled from TCM's library of 3,500 films with several considerations in mind. The film a poster promotes could be iconic, like *Rebel Without A Cause* on page 144. Or the poster could be iconic and the film, less so, like *The Outlaw* on page 26. We've also included posters from abroad for a few films, like *The Searchers* (*La Prisonnière Du Desert*) on pages 112–113, to show you how a Hollywood film was reinterpreted for audiences around the world. There are movies here that you'll know and movies you don't, but will love. After all, no classic film education would be complete without Roy Orbison's triumph in *The Fastest Guitar Alive* on page 116.

<div align="center">❦❦❦</div>

AS COLLECTIONS GO, THIS ONE IS ADMITTEDLY PLAYFUL. Like TCM, it takes risks with pleasure where classic movies are concerned. Our mission in life is not just to keep classic movies alive but to cultivate a new generation of classic movie fans. To us, movies are a strange and wonderful confluence of passion and technology that somehow transcends entertainment. ∗ They are the American Dream incarnate, born on Sunset Boulevard and nourished in every small town in America. They are the illusion that keeps reality at bay, war or depression be damned, and our bridge to other worlds, past lives, and future generations. ∗ Perhaps more than anything else, movies are bits and pieces of our collective cultural history. And when we lose them, we lose a little piece of ourselves, too. ∗ *Picture Show* is part of our efforts to prevent that. Now dim the lights and pass the popcorn. We're going to the movies.

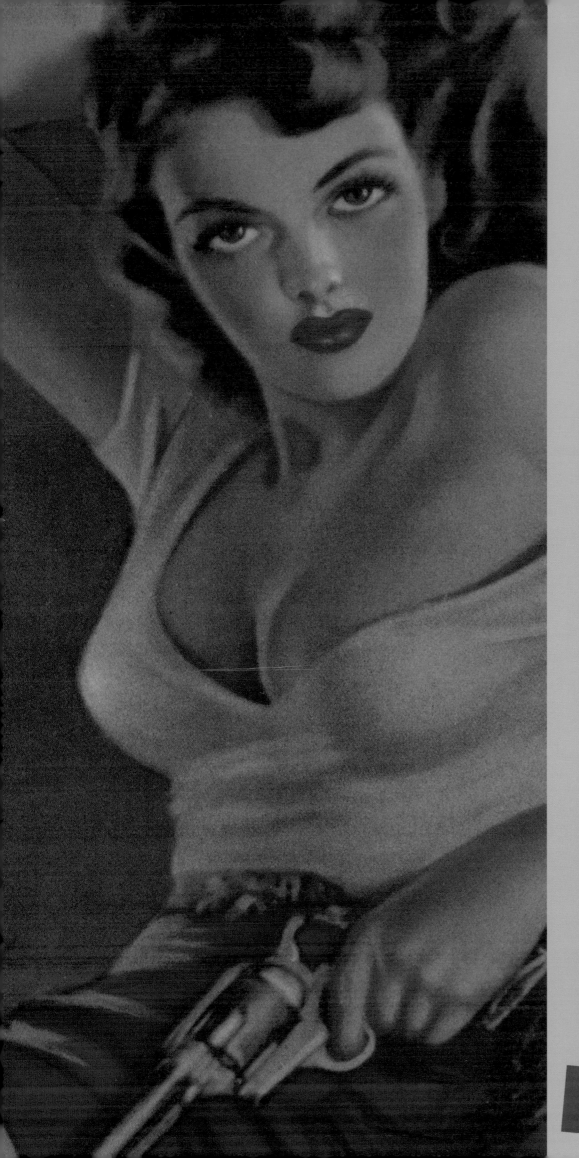

bad GIRLS

She Puts the "Fatale" in Femme.

Some girls would just as soon kill a man as kiss him. For others, the kissing is just where the killing starts. A Bad Girl is a siren-and-a-half, who wields her body like a weapon—unless a gun would work better—and there's no back she won't stab to get what she wants. Whether she marries for money or steals it, this is one hard-boiled babe. She can be a gangster's moll or the devil's daughter, but either way, she's got ice in her veins—and red, red lips that are as toxic as they are tempting.

Those red lips were likely the inspiration for the palette of hot, sensuous reds and yellows used so liberally in Bad Girl posters over the years. Curve-hugging gowns (usually strapless) and acres of milky-white skin were to the Bad Girl what the ten-gallon hat was to the cowboy: working clothes. A burning cigarette, a warm gun, or both, completed the look. And since no self-respecting Bad Girl would be caught dead smiling, hooded stares came to telegraph badness as surely as satin and lace.

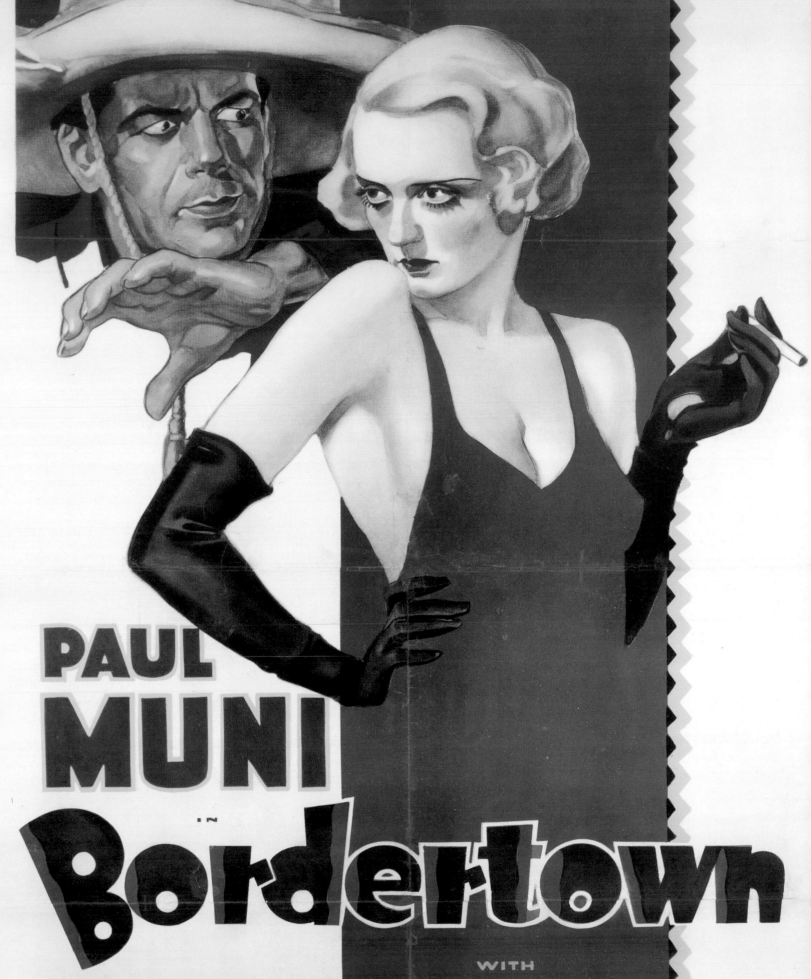

PAUL
MUNI
IN
Bordertown

WITH

BETTE
DAVIS

MARGARET LINDSAY
EUGENE PALLETTE
Directed by Archie L. Mayo
A WARNER BROS
Production Corp. Picture

Bordertown
1935 Warner Bros.

The sultry, unhappy wife (Bette Davis) of a nightclub owner falls hard for a swarthy bouncer in love with a society woman who's just toying with his . . . affections. Everybody gets burned in the heat.

The Postman Always Rings Twice
1946 MGM

A hot-blooded drifter meets a lonely wife with a body to die for (Lana Turner)—and eventually, everybody winds up dying for it. But not before some of the steamiest action on film. Definitive noir.

Satan Met a Lady
1936 Warner Bros.

Everyone wants a shot at the treasure, but this dame (Bette Davis) kills for it. Based on Dashiell Hammett's *The Maltese Falcon*, the bejeweled beastie this time around is a ram's horn.

following pages

Red Headed Woman
1932 MGM

Sensuous redhead (played by quintessential platinum blonde Jean Harlow) conquers every man in her zip code, from the boss to the chauffeur. Exposed but unrepentant, she moves on in search of bigger fish in Europe.

Baby Face (Liliane)
French
1933 Warner Bros.

A hard-nosed little trick (Barbara Stanwyck) canoodles her way from a small town speakeasy to a New York bank where she incites a murder-suicide and then breezily extorts her way to Paris.

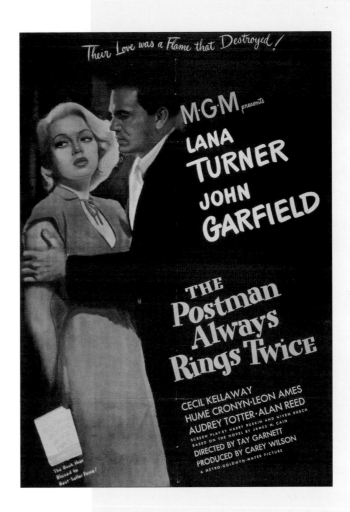

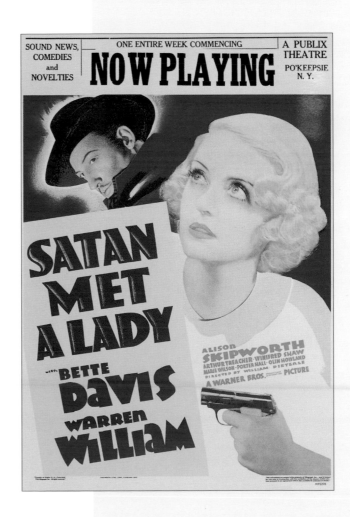

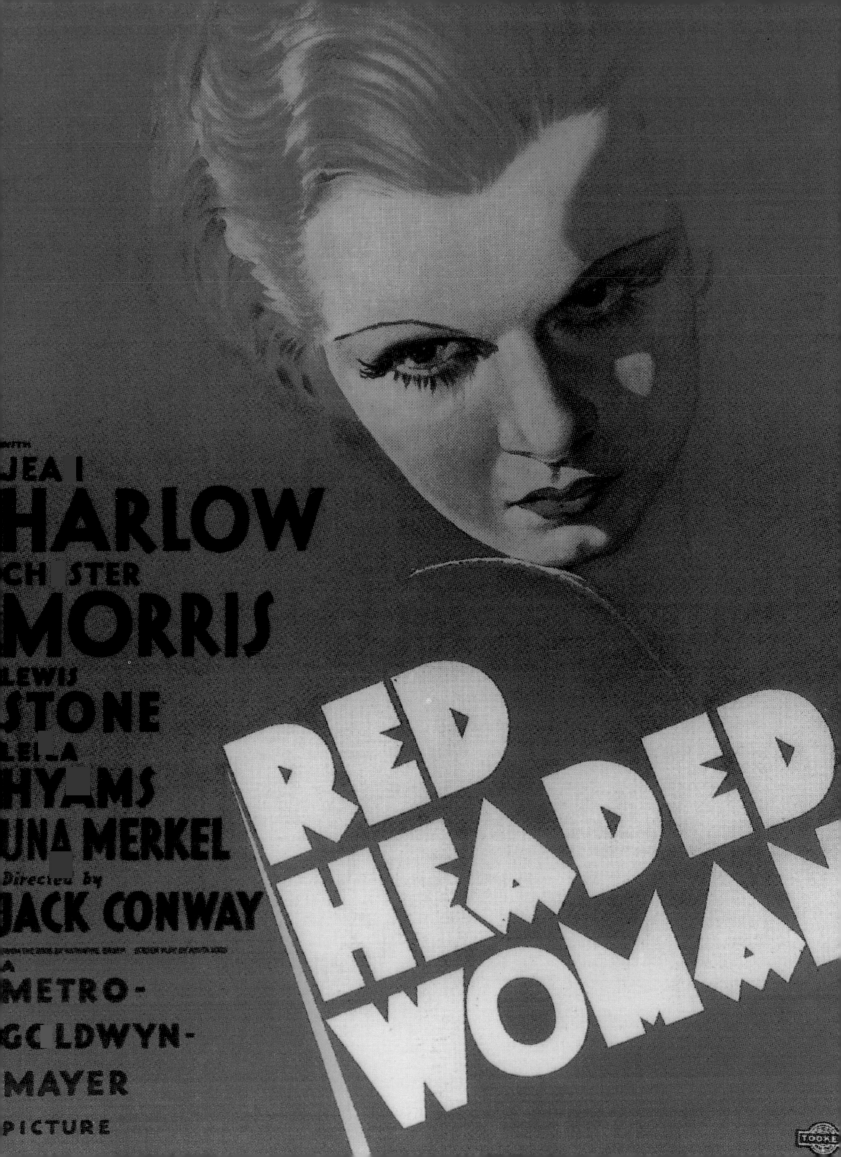

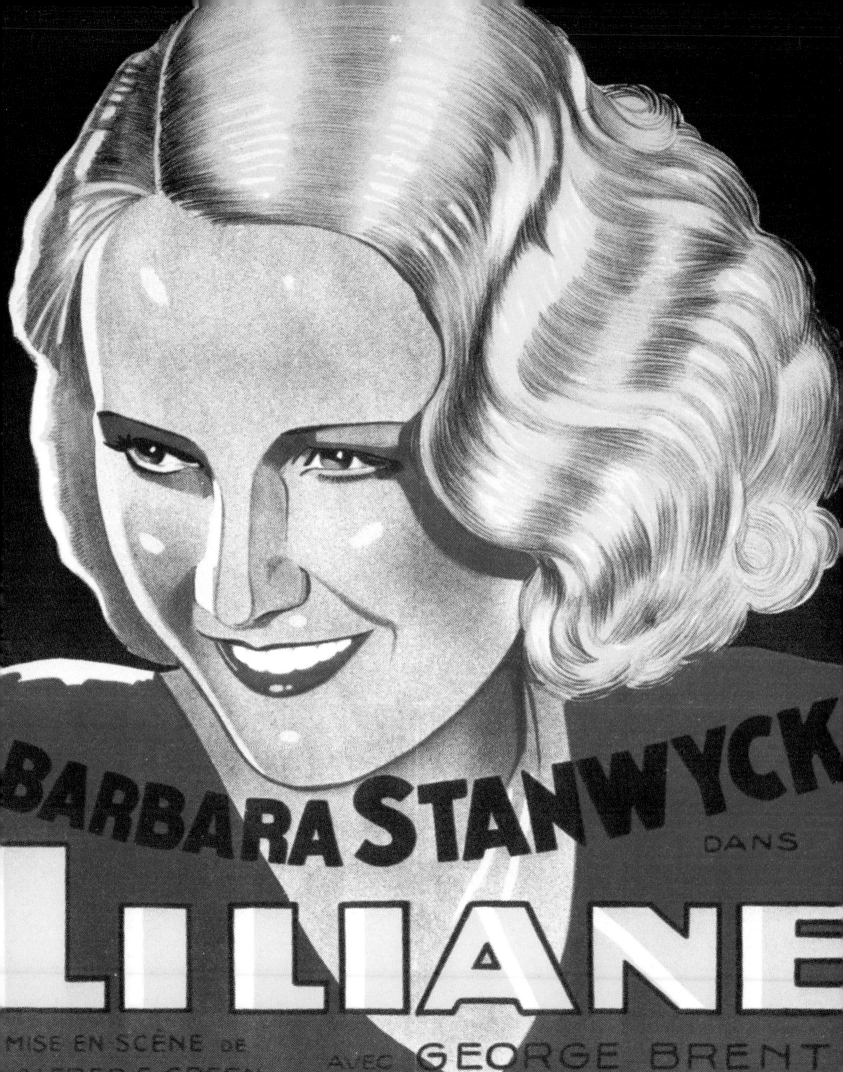

BARBARA STANWYCK DANS

LILIANE

MISE EN SCÉNE DE
ALFRED E. GREEN

AVEC GEORGE BRENT

UNE PRODUCTION WARNER BROS. FIRST NATIONAL FILMS INC.

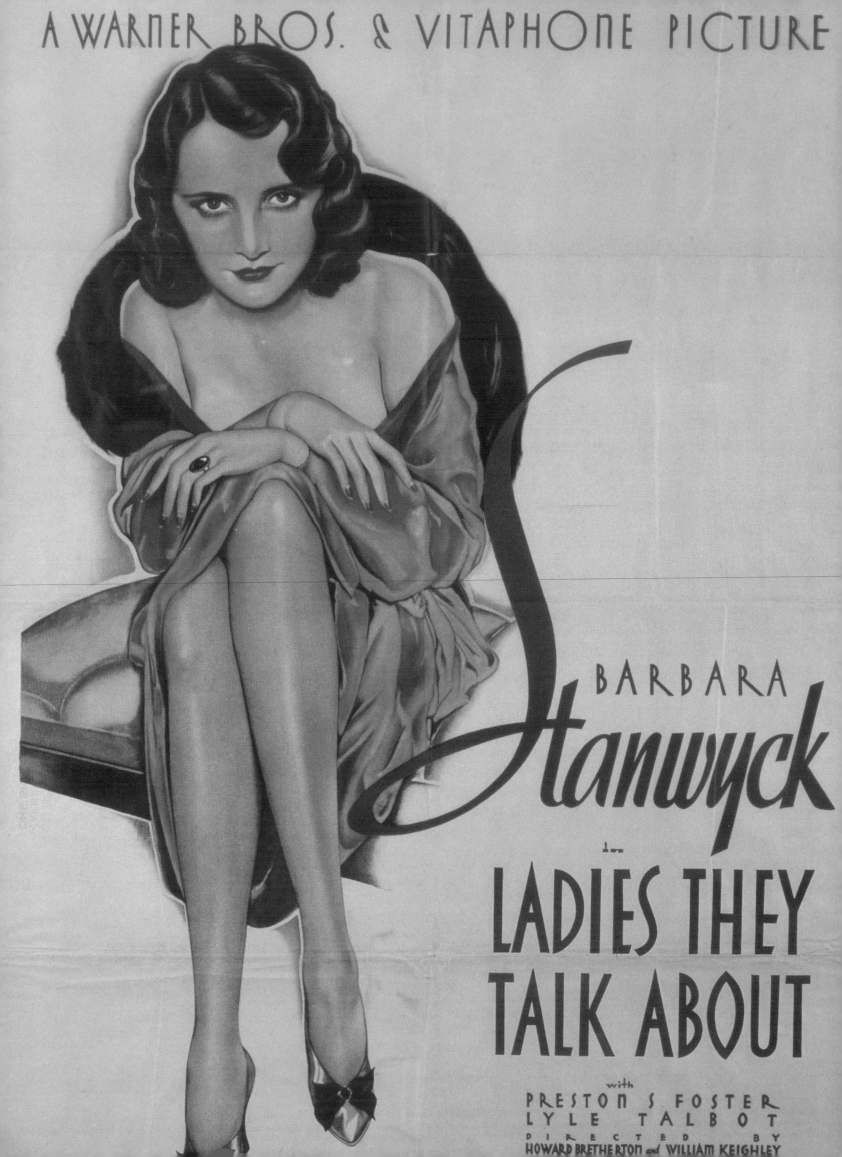

previous pages

Ladies They Talk About
1933 Warner Bros.

AKA, *Women in Prison*. Tough-talking, satin-wearing moll (Barbara Stanwyck) bides her time in San Quentin, waiting for the day she can shoot—and then fall for—the man who put her away.

Nora Prentiss
1947 Warner Bros.

Siren/singer (Ann Sheridan) bewitches a married doctor, and he fakes his death to be with her. She warbles as he goes on trial, is convicted, and heads to death row—for his own murder.

On the Loose
1951 RKO

Sure, sure, blame it on the parents. Neglected teenager waxes delinquent, develops a "reputation," eventually attempts suicide. Self-absorbed Mom and Pop finally snap out of it and take notice.

The Cobweb
1955 MGM

Battling bad girls declare war over window treatments. Kittenish doctor's wife (Gloria Grahame) rubs up to clinic director, angry spinster (Lillian Gish) counterattacks with vicious gossip. The pretense is drapery. The truth is power.

The Mask of Fu Manchu
1932 MGM

A beautiful, sadistic vamp (Myrna Loy) has a taste for torture, but her heart belongs to Daddy. Together, father and daughter plunder the tomb of Genghis Khan and almost destroy the world.

Lightning Strikes Twice
1951 Warner Bros.

Marrying a man who's just been acquitted of murdering his first wife isn't every woman's cup of tea. But for this "all-woman" actress (Ruth Roman), a dangerous man is the only kind that will do.

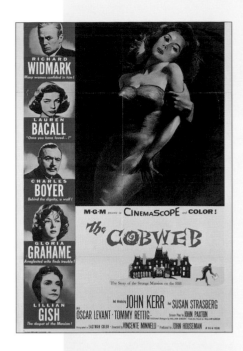

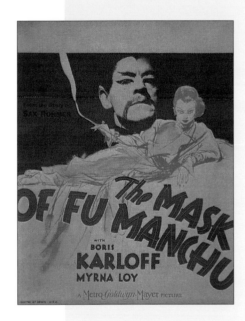

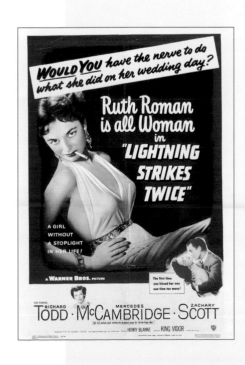

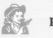

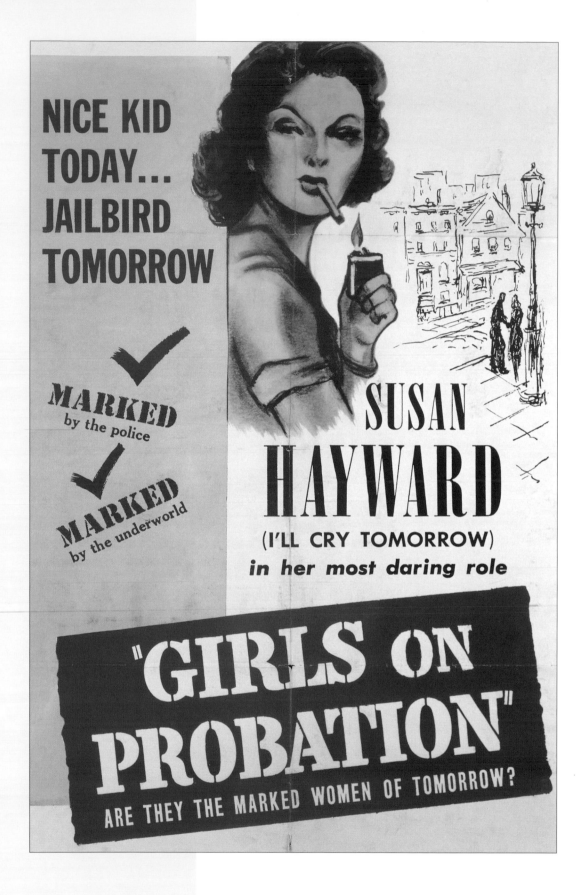

Girls on Probation
1938 Warner Bros.
A sweet young thing (Jane Bryan) is wrongly accused by a socialite (Susan Hayward) of stealing a gown, and it's all downhill from there. Cigarettes, car chases, and shoot-outs, with blackmail and remorse in between.

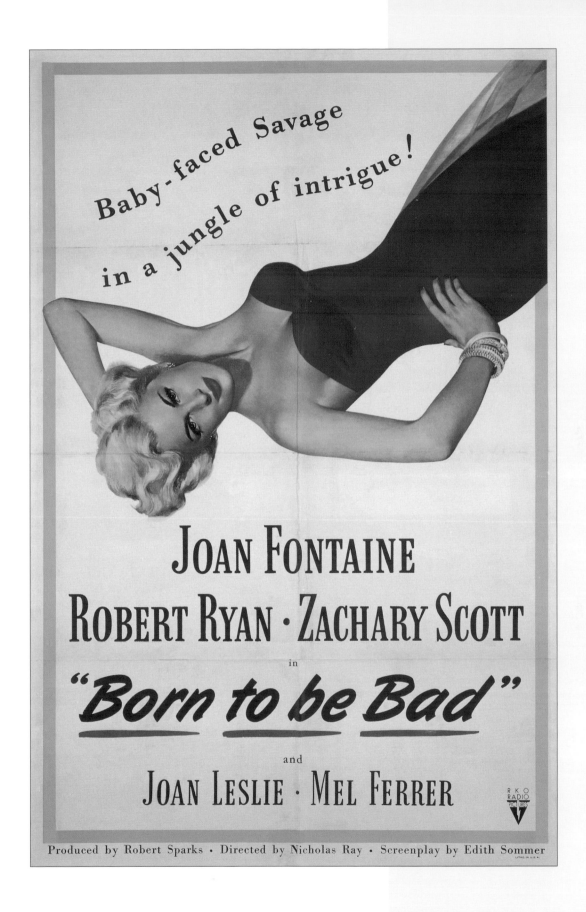

Born to be Bad
1950 RKO
Classic bad-girl fable without the usual
comeuppance. When the "baby-faced savage"
(Joan Fontaine) is revealed to be a heartless
schemer, she merely shrugs it off and goes
on to fresh victims.

HOWARD HUGHES' daring PRODUCTION

The Outlaw

introducing JANE RUSSELL

Mean.. Moody.. Magnificent

HOW WOULD YOU LIKE TO TUSSLE WITH RUSSELL ?

The Outlaw
1943 RKO

When the hot-tempered mistress (Jane Russell) of Doc Holliday tries to kill Billy the Kid, he falls for her head-over-spurs. After a literal roll in the hay, they ride off into the sunset.

Juke Girl
1942 Warner Bros.

"The Tomatoes of Wrath," starring a ripe-looking juke girl. Two friends part company when tomato growers go up against packers. There's a murder, a frame-up, and lots of smashed fruit.

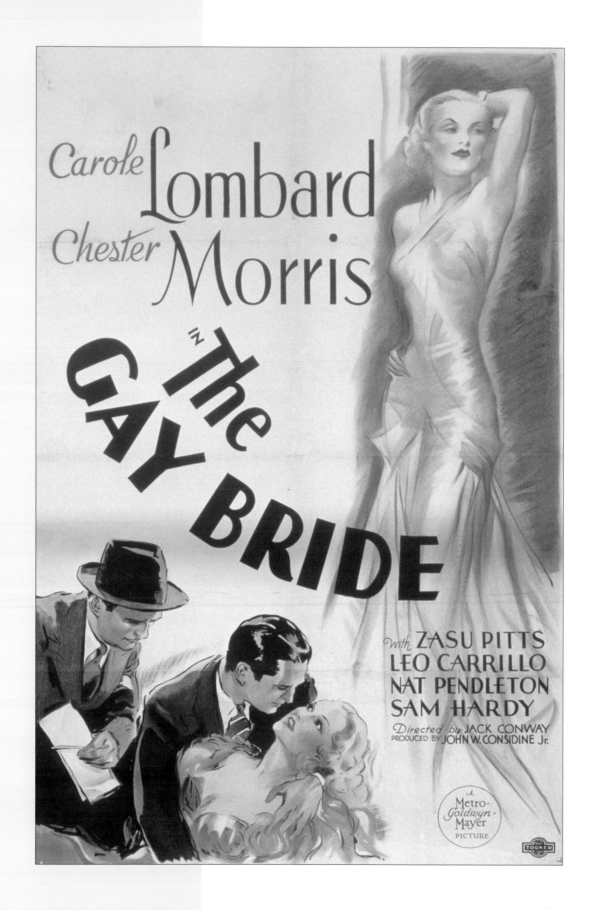

The Gay Bride
1934 MGM
A gold-digging showgirl (Carole Lombard)
marries a mobster in hopes of graduating
from gay bride to merry widow as soon as
possible. Until then, she happily swindles
him for everything he's worth.

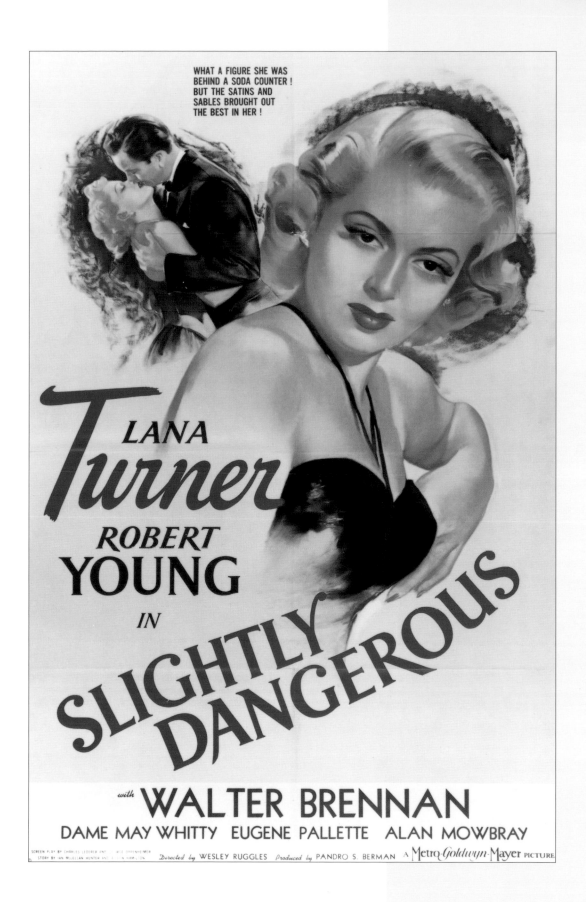

Slightly Dangerous
1943 MGM

A shapely soda jerkette's (Lana Turner)
apparent suicide costs her boss his job.
Starting fresh in New York, she fakes
amnesia and poses as the long-lost daughter
of a millionaire. Both men fall under her spell.

battle of
THE SEXES

He Said, She Said. Repeat.

Two people, one agenda: control. The power struggle between men and women is practically the oldest story on Earth. And in Hollywood's hands, it's one of the funniest. In these silver-tongued films, the battle lines run straight through the bedroom, and the enemy camps, like the bathroom towels, are marked His and Hers. The weapon of choice is the witty rejoinder, repartee that cuts to the quick without ever drawing blood. No matter how the argument begins, it always comes down to this: who's gonna wear the pants in this family and who's gonna iron them?

Posters sold these frothy acrimony-in-matrimony confections with vignettes of the sparring partners in action. Stylized, often cartoonlike illustrations showed the stars face to face in mock confrontation or back to back, smirking "gotcha" over their shoulders. Curved, hand-drawn titling, "madcap" copy, and a flurry of busy decorative touches kept the mood light so the audience would know that these enemies would kiss and make up before the credits rolled.

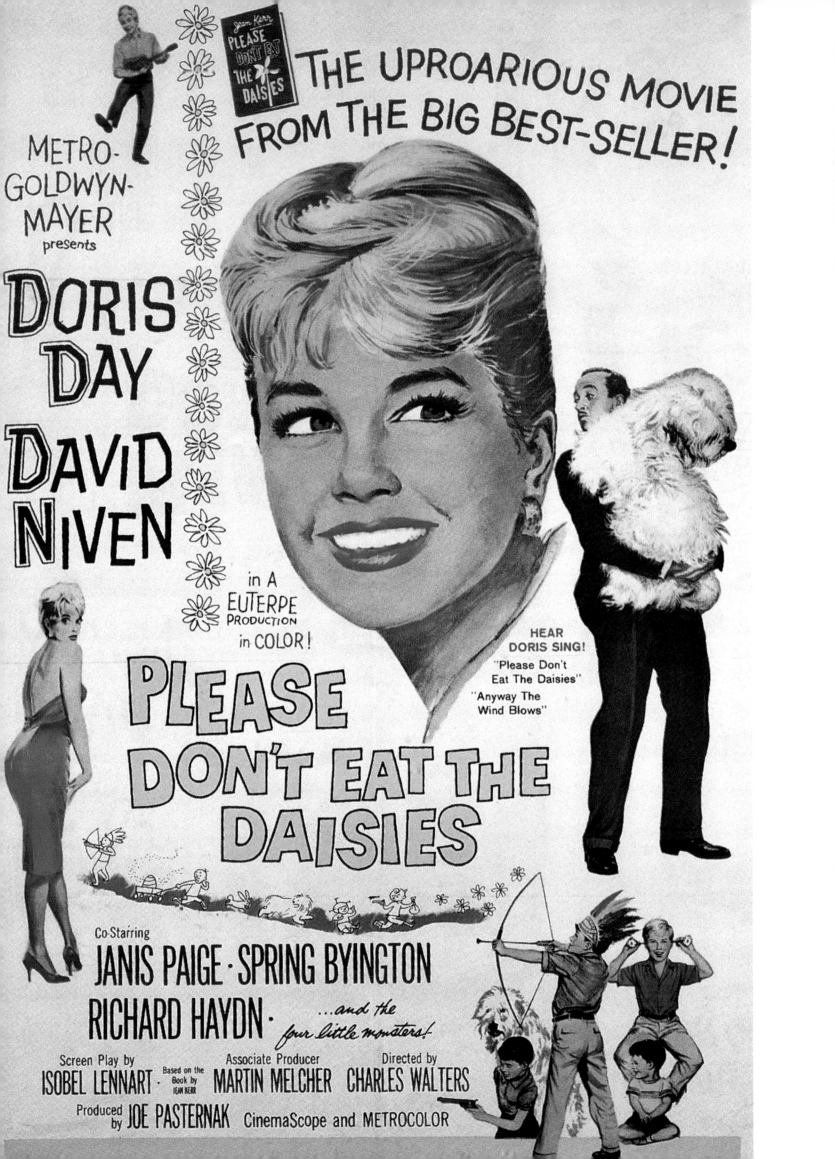

Please Don't Eat the Daisies
1960 MGM

A drama critic (David Niven) takes on Manhattan while his stressed-out spouse (Doris Day) takes on the kids, the dog, and pre-Prozac suburbia. Much mayhem ensues—but the daisies are saved.

The Reformer and the Redhead
1950 MGM

He's (Dick Powell) a "reform" candidate using blackmail to become mayor. She (June Allyson) believes he's a champion of the underdog who'll save her father's job at the zoo. Love and lions are soon unleashed.

Designing Woman
1957 MGM

The odd couple, sort of, with a chic fashion designer marrying an earthy sports writer after a romantic holiday fling. Back in the real world, they're worlds apart.

following pages

The Thin Man
1934 MGM

The first and most loved film in a long franchise. A retired detective (William Powell) marries a wealthy beauty (Myrna Loy), and together they dabble in martinis, murder, and repartee in the nightclubs and penthouses of Manhattan.

After the Thin Man
1936 MGM

Glamorous, amorous Nick and Nora Charles banter and sleuth their way through three murders and a missing husband with wit as dry as their gin. Canine companion Asta inspires a national terrier frenzy.

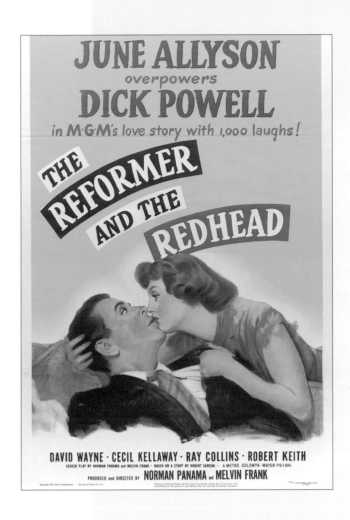

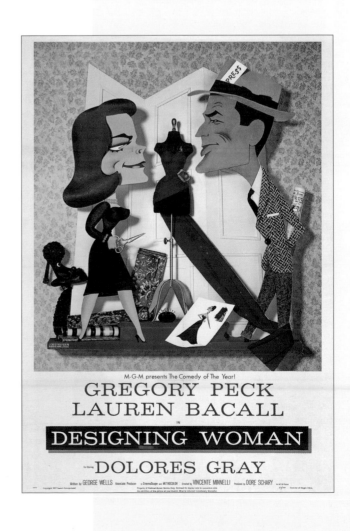

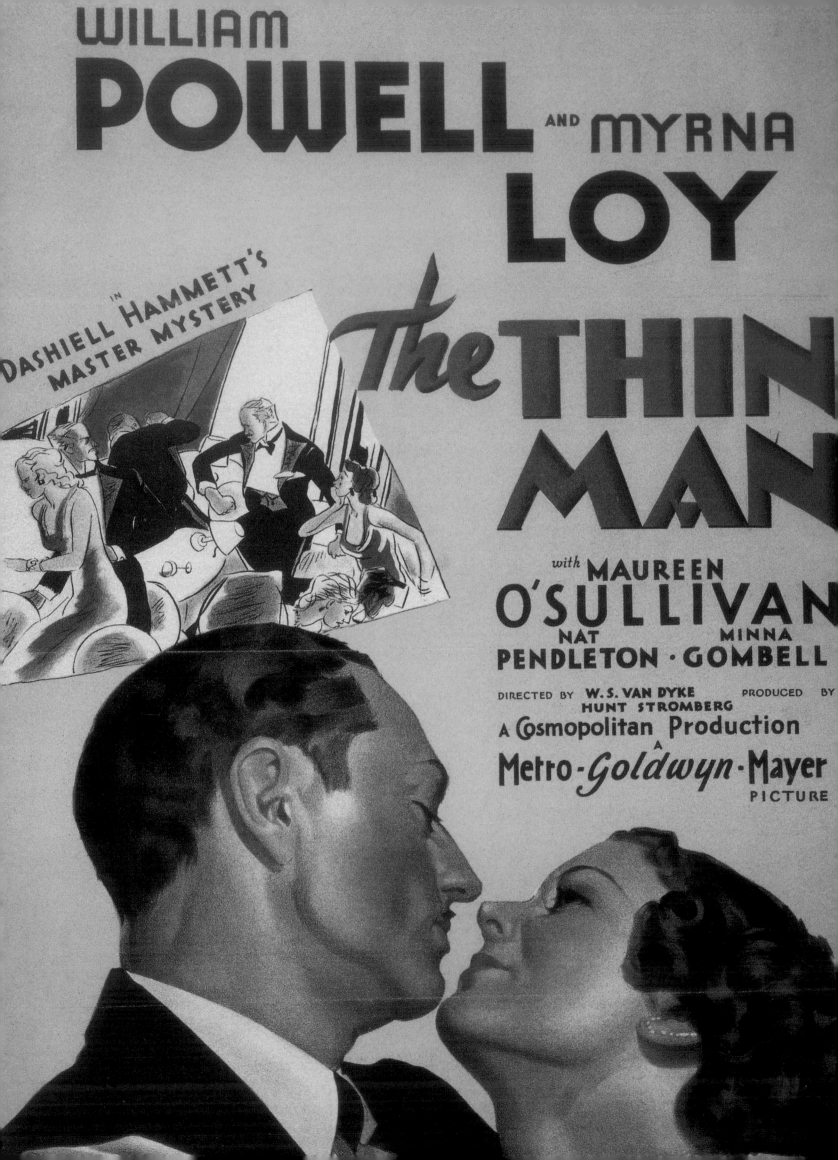

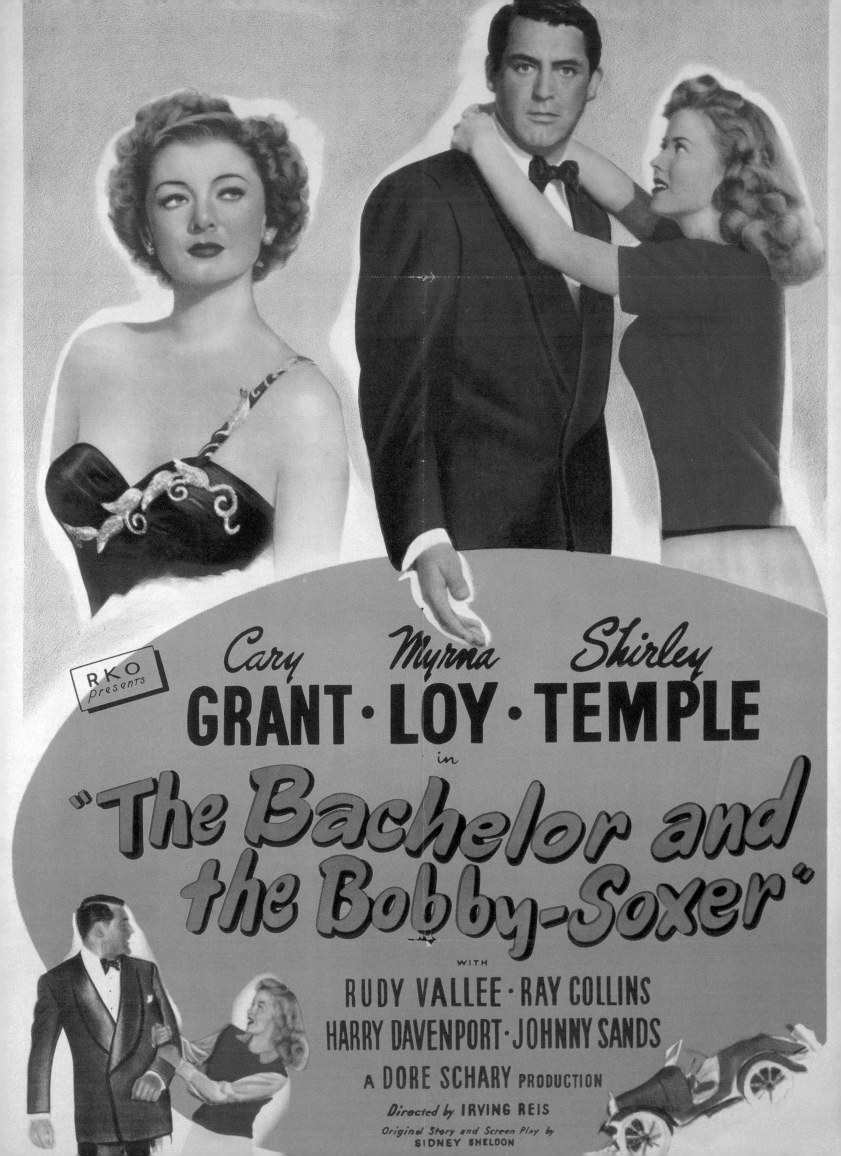

TENDER TRAP: "What Every Girl Sets For Every Man"

THE TENDER TRAP

GREAT ON THE STAGE!
TERRIFIC AS A MOVIE!

Starring

FRANK SINATRA · DEBBIE REYNOLDS
DAVID WAYNE · CELESTE HOLM

With JARMA LEWIS · Screen Play by JULIUS EPSTEIN · Based On the Play by MAX SHULMAN and ROBERT PAUL SMITH And Presented On the New York Stage by CLINTON WILDER

Photographed in EASTMAN COLOR · Directed by CHARLES WALTERS · Produced by LAWRENCE WEINGARTEN · AN M·G·M PICTURE

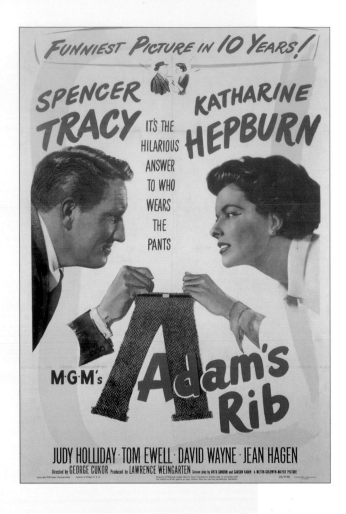

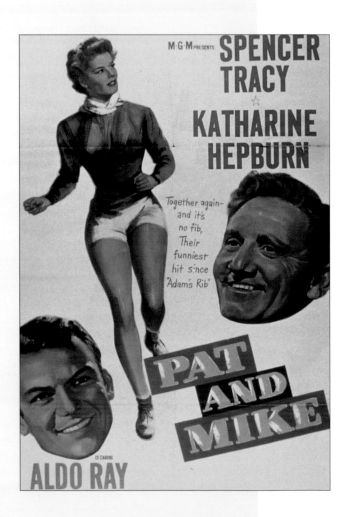

previous pages

The Bachelor and the Bobby-Soxer
1947 RKO

A no-nonsense judge (Myrna Loy) finds herself attracted to the suave bachelor (Cary Grant) who compromised her precocious teenaged sister in his hotel room . . . or did he? The judge wants the truth—and the handsome bachelor.

The Tender Trap
1955 MGM

A swinging New York bachelor (Frank Sinatra) has a penthouse full of beautiful women but loses his heart to a sweet young thing (Debbie Reynolds) determined to marry, move to the suburbs, and start a family within a year.

Adam's Rib
1949 MGM

Husband-and-wife lawyers (Spencer Tracy/Katharine Hepburn) are on opposite sides of the courtroom in a husband-against-wife case involving hanky-panky and firearms. Soon the bickering spills over from the courtroom to the bedroom.

Pat and Mike
1952 MGM

A sports promoter tries to ride a spunky, athletic PE teacher into the winner's circle of women's sports. When his crooked partners and her sabotaging fiancé show up, things really get physical.

Woman of the Year
1942 MGM

A celebrated, opinionated news columnist (Katharine Hepburn) battles her paper's stodgy, old-fashioned sports columnist (Spencer Tracy) all the way to the altar—and beyond. She wants a career in the spotlight; he wants a wife at home. Who wins?

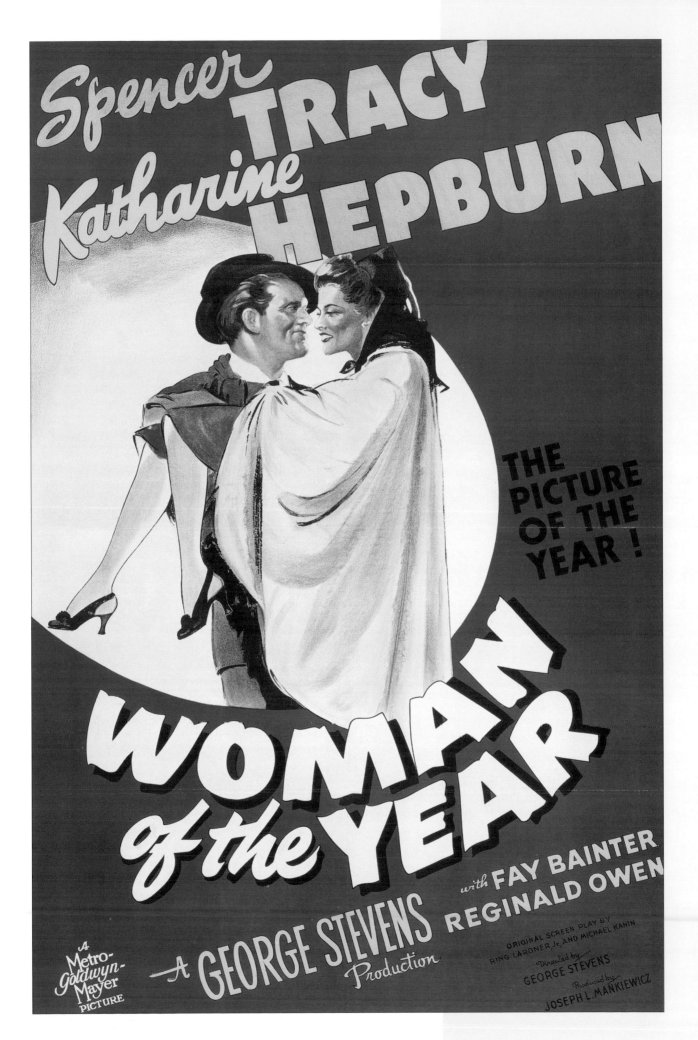

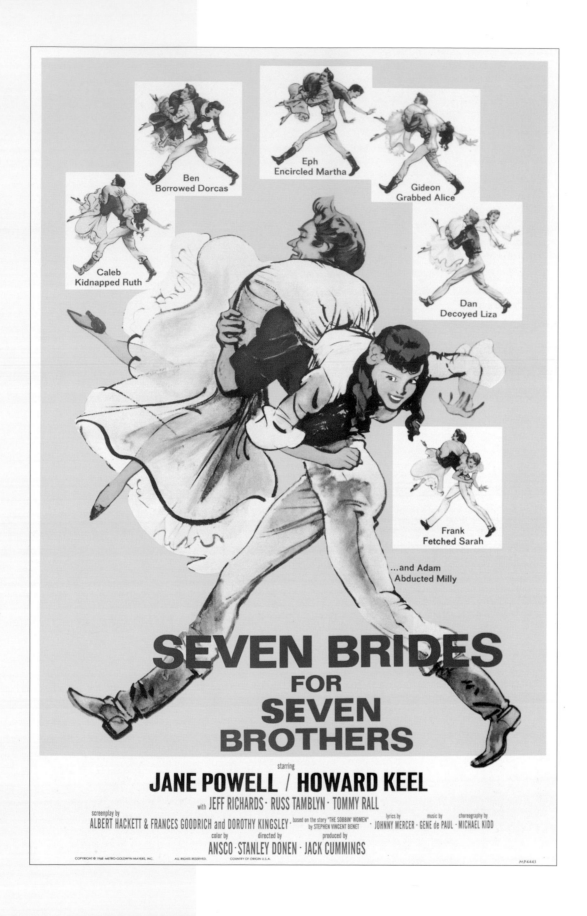

Seven Brides for Seven Brothers
1954 MGM
When a shy rancher (Howard Keel) woos a bride (Jane Powell) to his wilderness home, he neglects to tell her that his six rough-and-tumble brothers will be sharing their love nest on the prairie—until they find brides of their own.

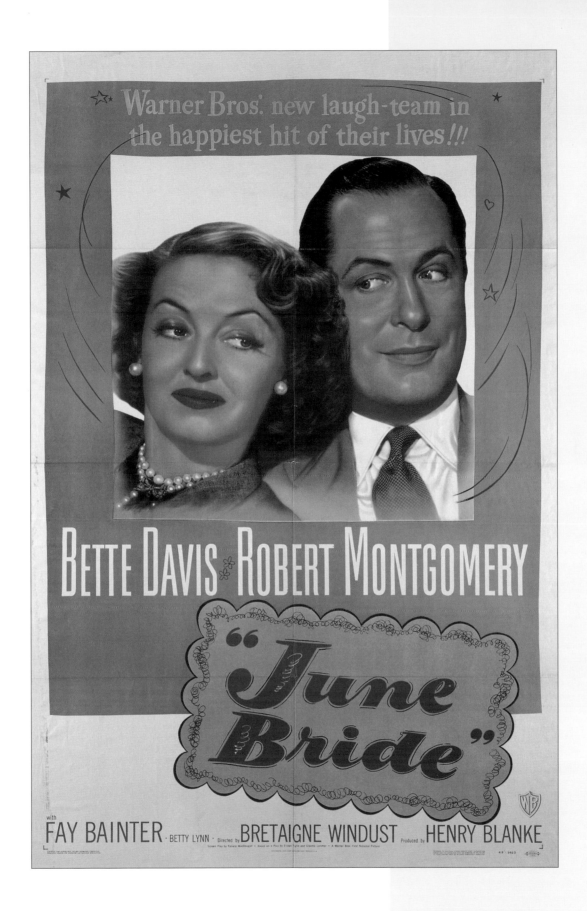

June Bride
1948 Warner Bros.
The ultramodern editor of a woman's magazine (Bette Davis) bosses her old flame (Robert Montgomery), a reporter covering the typical American wedding. Wordplay turns to horseplay when their flame reignites.

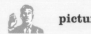

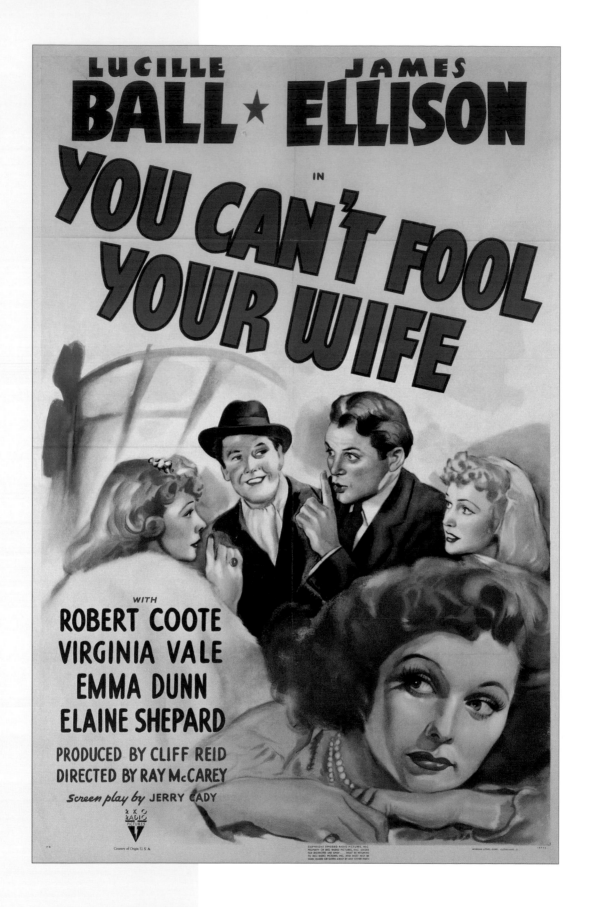

You Can't Fool Your Wife
1940 RKO

To save her marriage, a mousy woman
(Lucille Ball) masquerades as an exotic mys-
tery woman and flirts with her husband
(James Ellison) at a party. He knows, but
she doesn't know he knows.

Mr. Blandings Builds His Dream House
1948 RKO

Mr. and Mrs. Blandings (Cary Grant/Myrna
Loy) trade manic Manhattan for the fresh
air and rock-ribbed hills of Connecticut.
Country curmudgeons, waterless wells, and
a ham named Wham threaten their utopia.

drama QUEENS

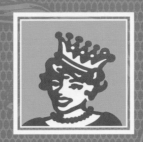

Made You Look!

You can't take your eyes off her, and that's the way she likes it. It isn't because she's beautiful, although she usually is. A Drama Queen needs an audience to live, and you are it, my friend. Her moods are volcanic and her appetites are legend. She can be good or she can be bad, but she cannot be ignored. She must be the center of attention, and if she isn't, well, she never met an uproar she didn't like. When she finally makes her exit, all she leaves in her wake is the pungent scent of high drama and heavy perfume.

The more a film revolved around its Drama Queen, the more she dominated its promotions. Poster artists surrounded worshipful "big head portraits" with delicately balanced titling. Her majesty's name was often as big as, if not bigger than, the title itself. The most powerful actresses negotiated "above the title" billing, fueling the perception that Drama Queens often played their part, both on screen and off.

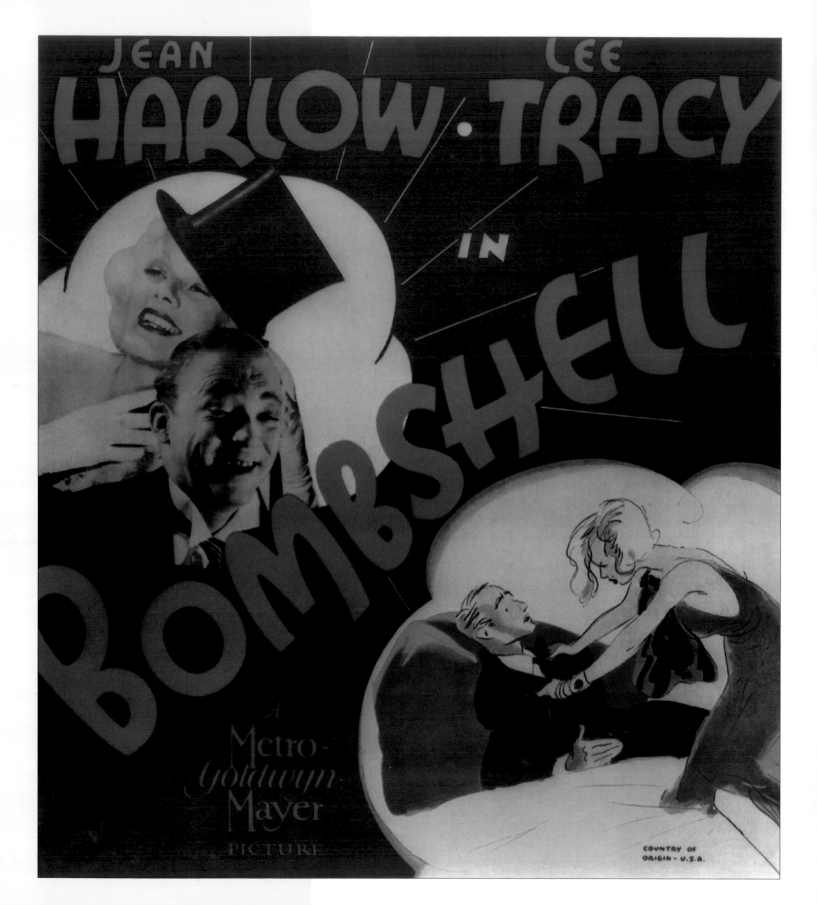

Bombshell
1933 MGM

This Hollywood spoof has a sexpot (Jean Harlow) daydreaming about wedding a titled aristocrat and adopting a baby while fending off mooching relatives and a conniving, double-crossing agent.

Cat on a Hot Tin Roof
1958 MGM

Hot blood and old money turn combustible when Big Daddy demands grandchildren from favorite son Brick, who'd rather mourn his dead "friend" than jump his wife Maggie's (Elizabeth Taylor) bones.

Torch Song
1953 MGM

Love is blind—literally—in this backstage love story. A difficult, compulsive Broadway star (Joan Crawford) finally meets her match in a blind pianist who sees right through her.

following pages

Dark Victory
1939 Warner Bros.

A hard-drinking, high-living heiress (Bette Davis) finally sees the light about life and love when those headaches turn out to be a brain tumor that will take her sight—and just hours later, her life.

The Velvet Touch
1948 RKO

A now familiar story in which a celebrity (Rosalind Russell) gets away with murder. This film swings on the star's moral dilemma: Should she confess when an innocent man is convicted?

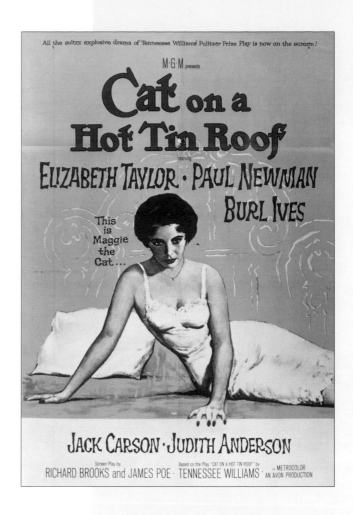

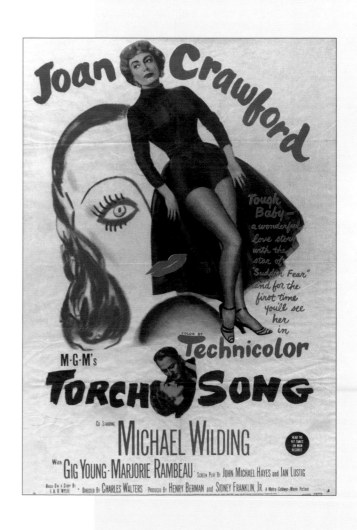

Rosalind Russell
in
THE VELVET TOUCH

A FREDERICK BRISSON PRODUCTION
also starring

Leo Genn · Claire Trevor
Sydney Greenstreet

with

LEON AMES · FRANK McHUGH · WALTER KINGSFORD · DAN TOBIN

DIRECTED BY **JOHN GAGE** · SCREEN PLAY BY **LEO ROSTEN**

An INDEPENDENT ARTISTS PICTURE · Released by RKO Radio Pictures

INDEPENDENT
ARTISTS
PICTURE

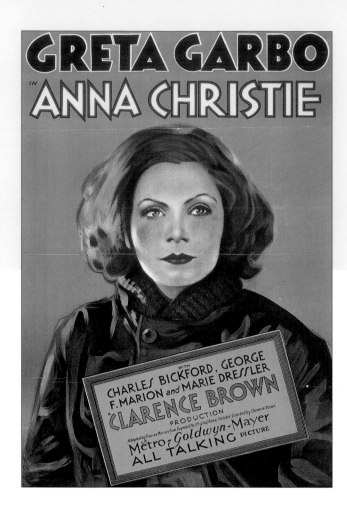

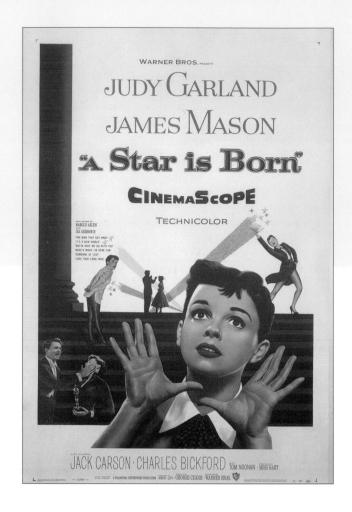

Anna Christie
1930 MGM

Swedish-American streetwalker gets off the
sauce by getting on the boat with the father
she never knew. Typecasting for Greta
Garbo's heavy accent, heard for the first time
on screen growling, "Gimme viskey . . ."

A Star Is Born
1954 Warner Bros.

In this what-price-fame morality tale, a
young singer on the way up (Judy Garland)
marries a star on the way down. When he
goes down in flames, will she let him take
her career down with him?

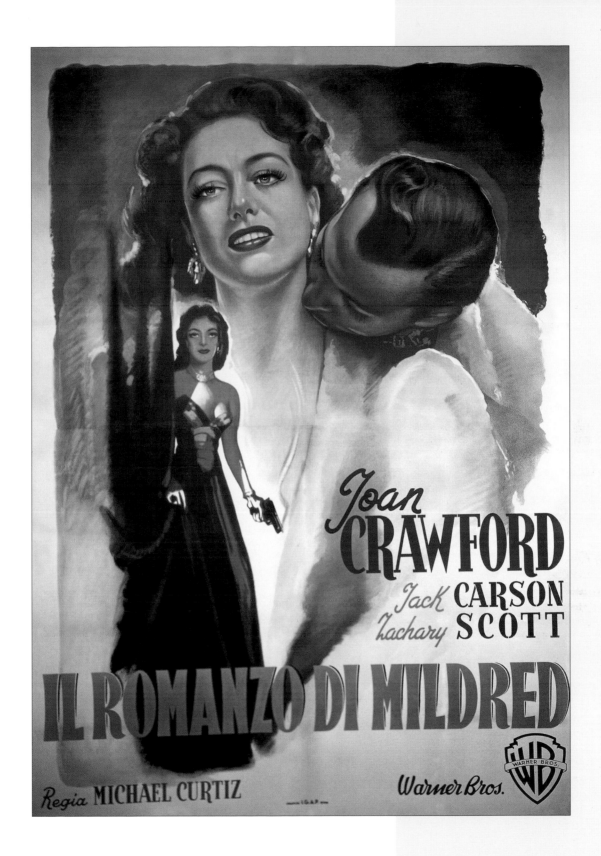

Mildred Pierce (Il Romanzo di Mildred)
Italian (Translation: The Story of Mildred)
1945 Warner Bros.
Her marriage over, Mildred Pierce (Joan
Crawford) turns her baking skills into an
empire, then marries an aristocrat for
cachet. The cad's got eyes for her daughter,
a snake in woman's clothing.

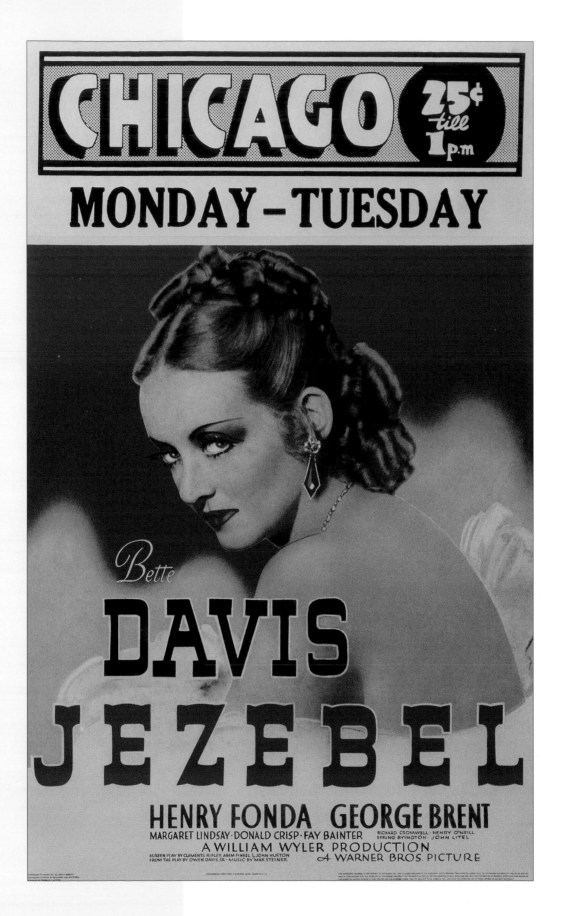

Jezebel
1938 Warner Bros.
The Southern belle from hell (Bette Davis)
makes her beau—and all of New Orleans
society—see red by wearing the wrong
gown. An epidemic of "yellow jack" comes
along to redeem her.

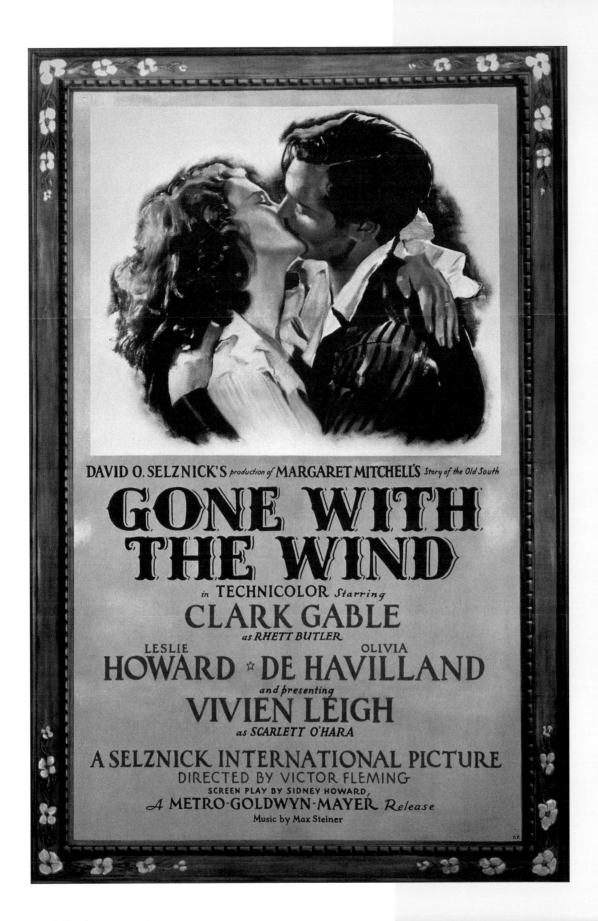

Gone with the Wind
1939 MGM
Love in the Time of Cotton. Beautiful
Southern belle (Vivien Leigh) pursues the
man of her dreams, only to find he isn't the
man she loves. Classic, "Be careful what you
wish for. . . ."

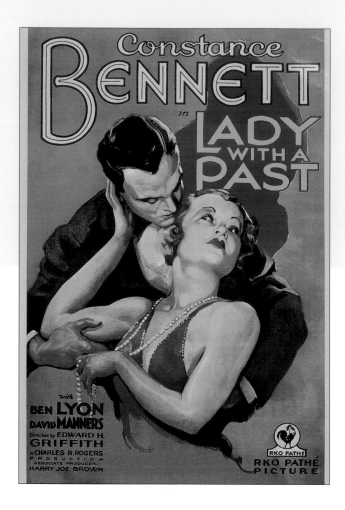

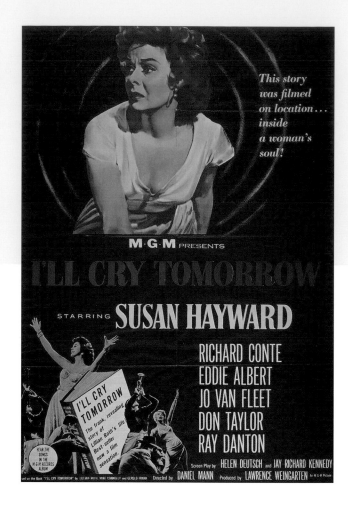

Lady with a Past
1932 RKO

Bashful lovely (Constance Bennett) bored
with her ho-hum love life hires an escort for
a Parisian tour where she fabricates a "repu-
tation" in hopes of attracting more exciting
suitors. Her fabulous gowns help.

I'll Cry Tomorrow
1955 MGM

Tempestuous singer Lillian Roth (Susan
Hayward) takes a boozy journey to hell and
back, kick-started by her wicked stage
mother (Jo Van Fleet) and the death of her
first husband. A biopic as jagged as the
morning after.

The Women
1939 MGM

Sweet Mary's (Norma Shearer) husband is
having an affair with a predatory shop girl
(Joan Crawford) and her helpful "friends"
(Rosalind Russell/Phyllis Povah) make sure
she finds out. High–society backstabbing,
husband stealing, and catty gossip.

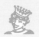

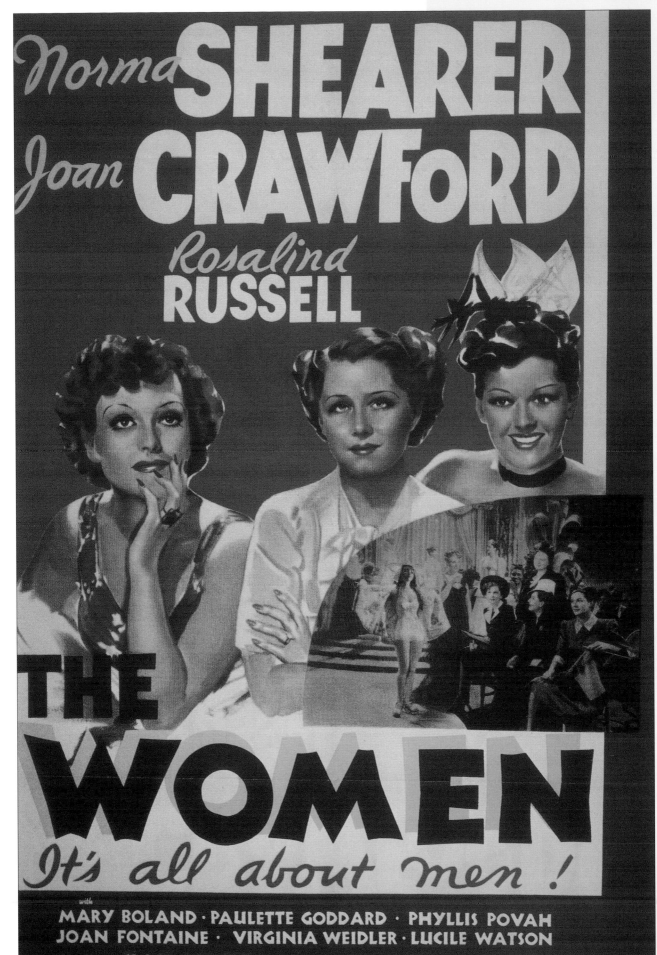

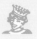

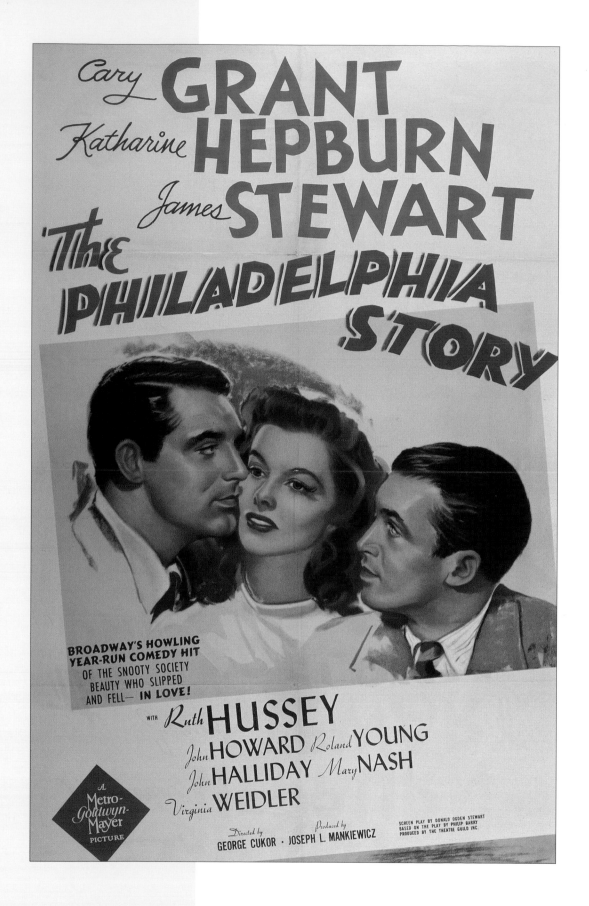

The Philadelphia Story
1940 MGM
A socialite's (Katharine Hepburn) wedding to a stuffed shirt attracts the attention of tabloid reporters and her ex-husband. A wild night of highballs later, the wedding is off. Or is it?

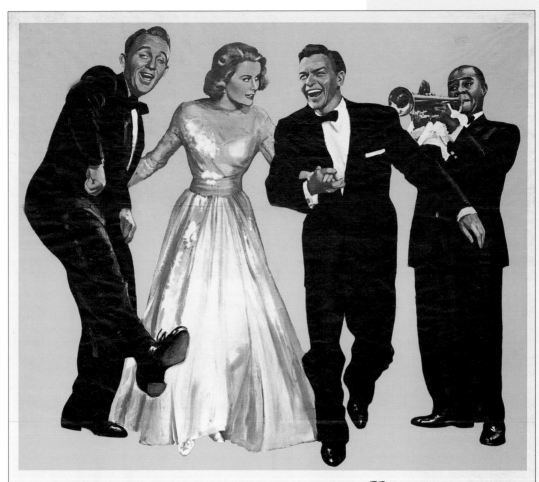

A NEW HIGH IN THE MOVIE SKY. M-G-M PRESENTS IN VISTAVISION AND COLOR
A SOL C. SIEGEL PRODUCTION

Starring

BING CROSBY ★ GRACE KELLY ★ FRANK SINATRA

in the hilarious low-down on high life

High Society

co-starring

CELESTE HOLM · JOHN LUND

LOUIS CALHERN · SIDNEY BLACKMER

and LOUIS ARMSTRONG and His Band

Screen Play by JOHN PATRICK Based on a Play by PHILIP BARRY

Music and Lyrics by COLE PORTER

Color by TECHNICOLOR Directed by CHARLES WALTERS

High Society
1956 MGM

This time, *The Philadelphia Story*'s jazzed up
with Satchmo and crooners Crosby and
Sinatra. A socialite's (Grace Kelly) wedding to
a wealthy prig hits a bump when she finds
herself attracted to both her ex-husband and
a reporter covering the nuptials.

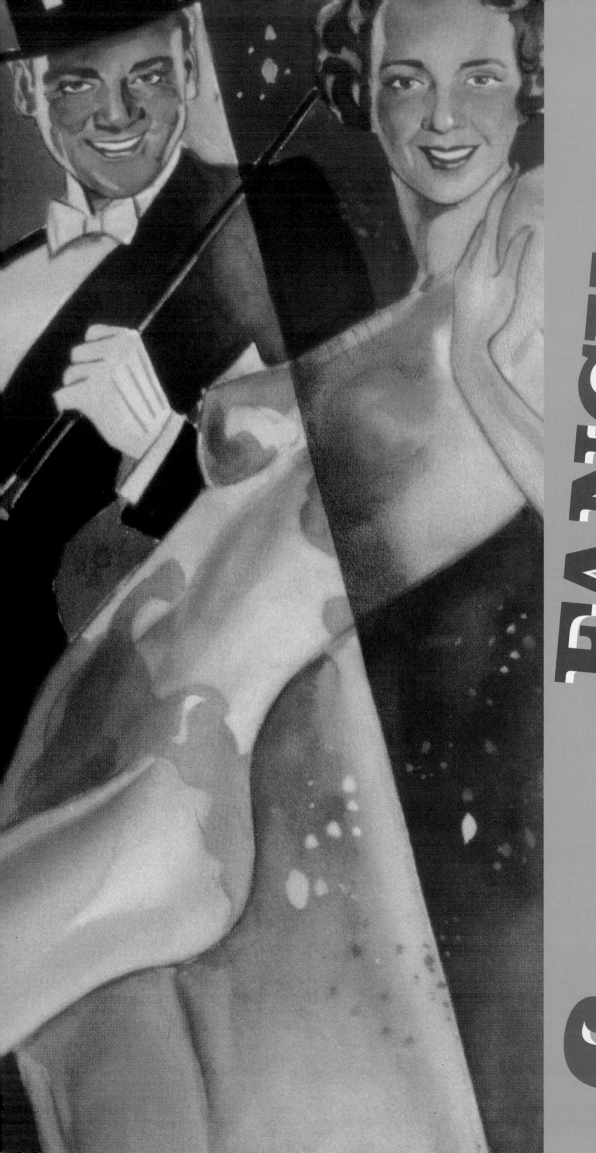

FANCY footwork

Gotta Sing! Gotta Dance!

She's the love child of Broadway and vaudeville and the mother of the music video—and as downright American as film gets. Classic American musicals are a celebration of art deco and satin, plumage and pearls, and high-kicking kitsch. In early films, the decadent Follies provided the excuse for the most extravagant production numbers ever staged. But soon, music and dance were just dropped into stories like a sugar cube into a champagne cocktail, with equally intoxicating results. No matter how provocative the costumes or how tricky the choreography, the stories stayed sweet and the stars kept shining.

Sing out the news! It's a honey of a show! Everything about musical posters is over the top. The designs are as frenetic as the films themselves, bright and cluttered and buzz-buZZ-BUZZing with energy. If the confetti and stars and prancing musical notes don't grab you, the crowing copy and !!! will. How could any fan resist "the greatest production since the birth of motion pictures"—especially in that marvelous innovation called Technicolor?

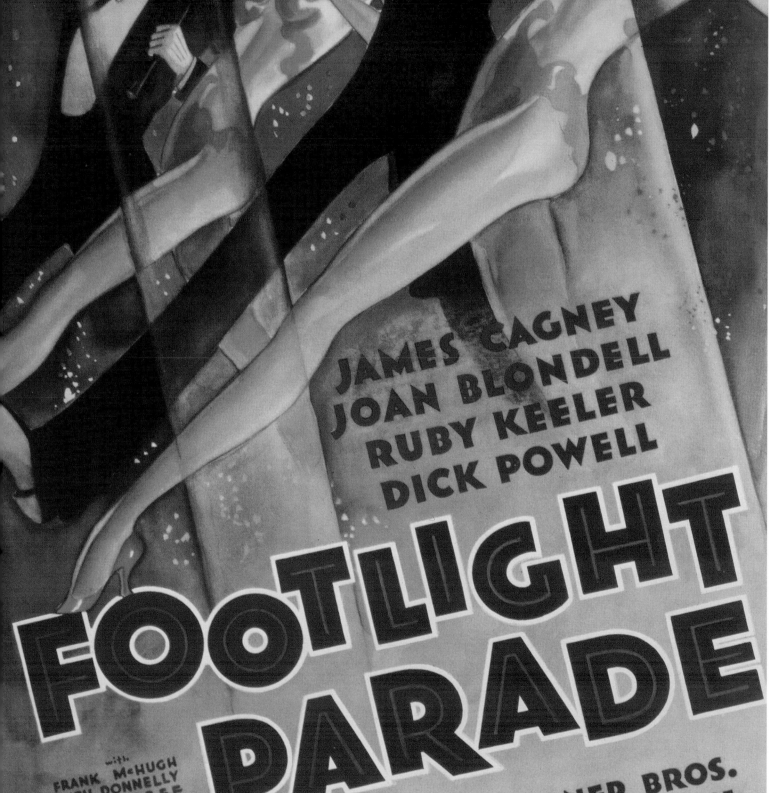

JAMES CAGNEY
JOAN BLONDELL
RUBY KEELER
DICK POWELL

FOOTLIGHT PARADE

with
FRANK McHUGH
RUTH DONNELLY
GUY KIBBEE
HUGH HERBERT
DIRECTED BY
LLOYD BACON
NUMBERS CREATED AND STAGED BY
BUSBY BERKELEY

A WARNER BROS.
& VITAPHONE PICTURE

Footlight Parade
1933 Warner Bros

A backstage musical drama in which a theater producer (James Cagney) struggles to save live theater from the talkies by mounting lavish musical "prologues" before films. Classic Busby Berkeley production numbers.

Du Barry Was a Lady
1943 MGM

Bookend redheads in Technicolor! A showgirl (Lucille Ball) won't give the lowly coatroom guy (Red Skelton) a second look until he wins a fortune and buys the nightclub where they work.

The Band Wagon
1953 MGM

An aging Hollywood hoofer (Fred Astaire) comes to Broadway for a last hurrah and is partnered with a tall, leggy dancer (Cyd Charisse) who thinks he's too old for her. When they pull together, they get a hit.

following pages

The Gay Divorcee
1934 RKO

An unhappily married woman (Ginger Rogers) mistakes an American dancer (Fred Astaire) at a seaside resort for the corespondent her lawyer has hired to provide her with the grounds for a divorce.

Singin' in the Rain
1952 MGM

THE iconic musical. Silent-film stars wrestle with the coming of talkies. A buzz-saw voiced sexpot uses a chorus girl (Debbie Reynolds) as her voice double until the leading man (Gene Kelly) drops the curtain on her act.

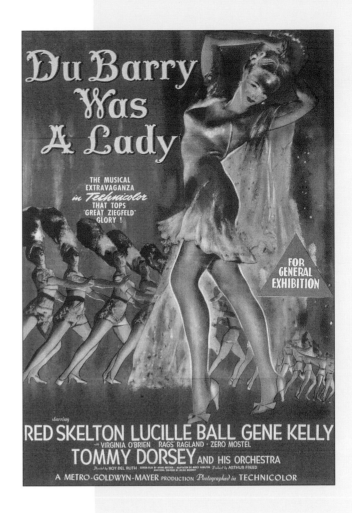

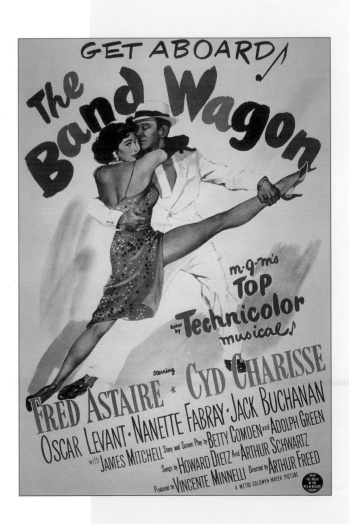

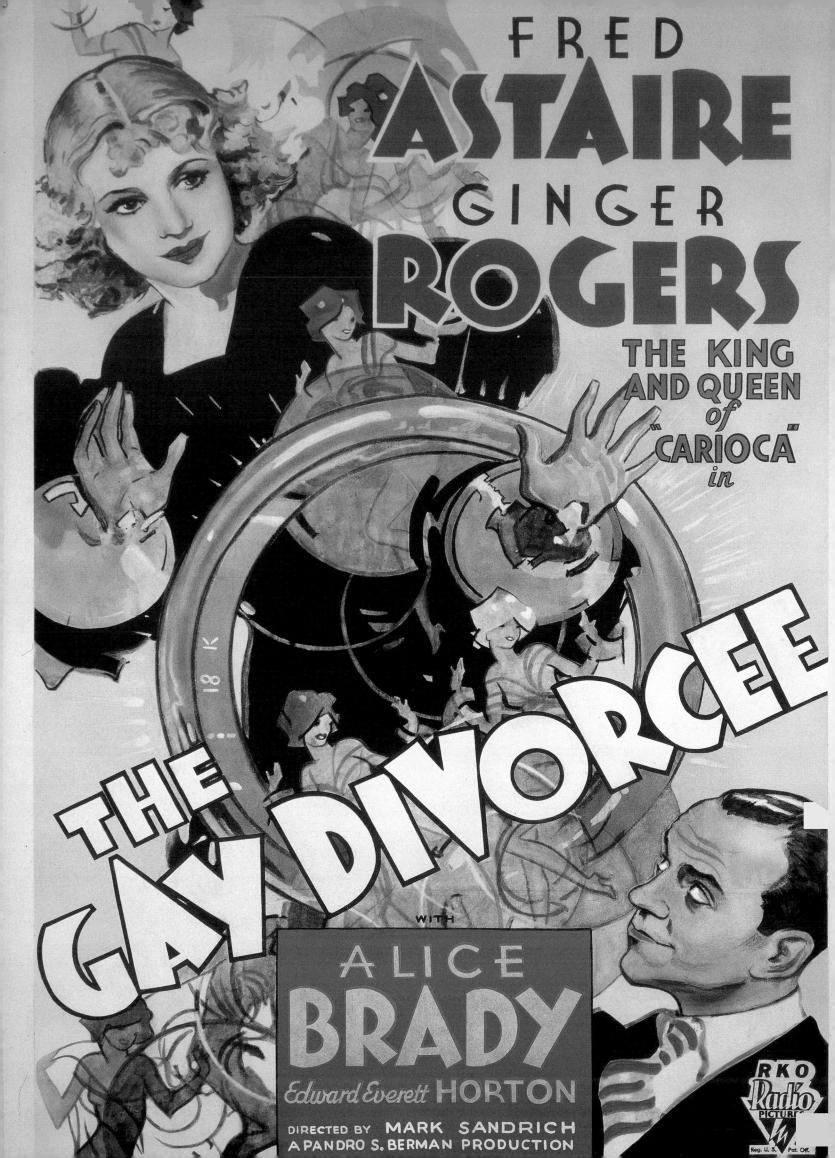

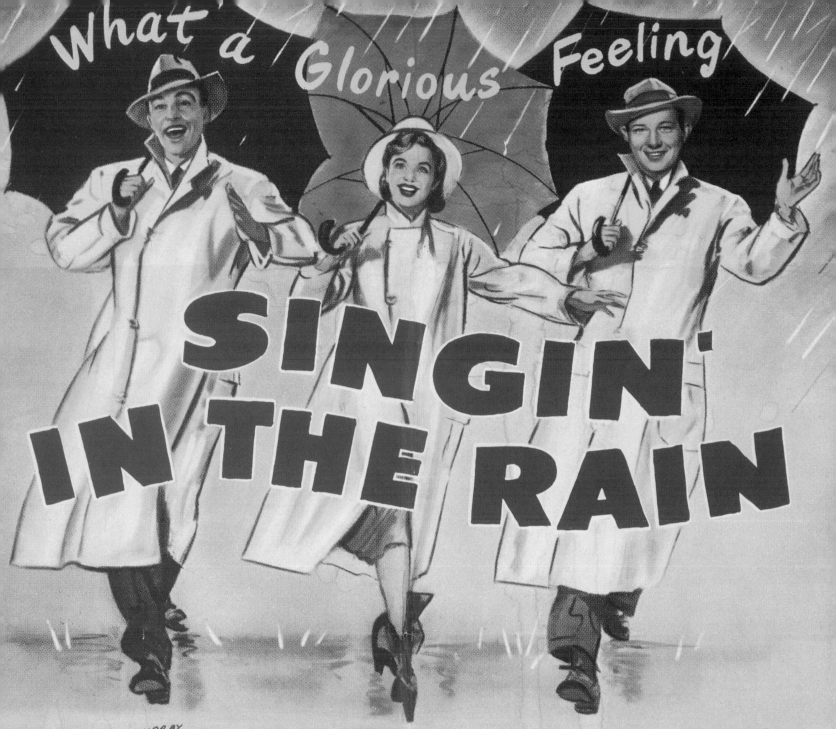

What a Glorious Feeling

SINGIN' IN THE RAIN

COLOR BY MGM's TECHNICOLOR MUSICAL TREASURE!

Starring

GENE KELLY
DONALD O'CONNOR
DEBBIE REYNOLDS

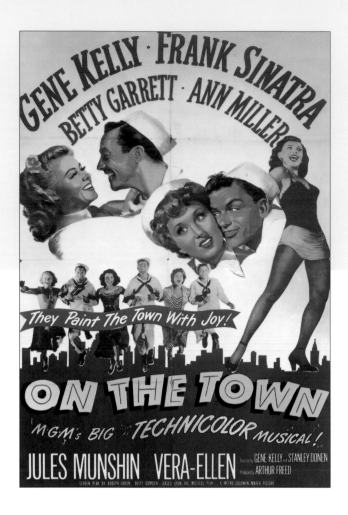

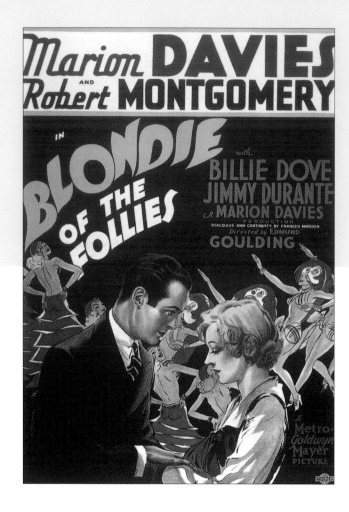

On the Town
1949 MGM

Three sailors (Gene Kelly/Frank Sinatra/
Jules Munshin) on twenty-four-hour shore
leave in New York search for "Miss Turn-
stiles" (Vera-Ellen), helped by a comely
cabbie (Betty Garrett) and a dancing
anthropologist (Ann Miller).

Blondie of the Follies
1932 MGM

Sassy "good girl" Blondie (Marion Davies)
follows her "bad girl" friend (Billie Dove)
into the Follies, and they both fall for a
wealthy patron (Robert Montgomery).
Backstage backstabbing with lots of sequins
and champagne.

Brigadoon
1954 MGM

A jaded New Yorker (Gene Kelly) hunting in Scotland gets lost in the mist and stumbles into a surreal village that materializes once every 100 years. Will he give up the twentieth century for the bonnie villager (Cyd Charisse) he loves?

Broadway Melody of 1938
1937 MGM

A Broadway producer (Robert Taylor) and his star (Eleanor Powell) get the money to back his show when her racehorse wins at Saratoga. Then a mesmerizing young star (Judy Garland) steals the show from both of them.

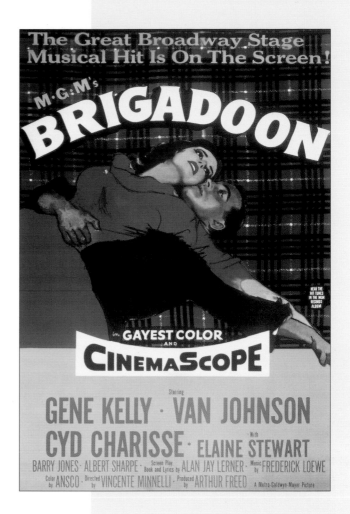

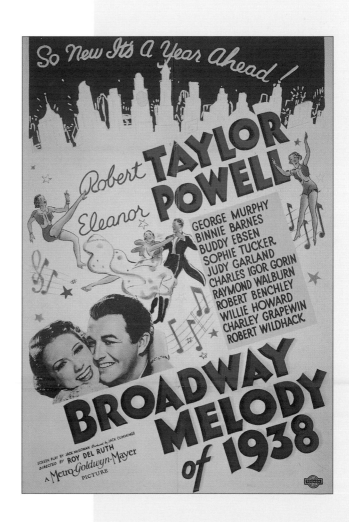

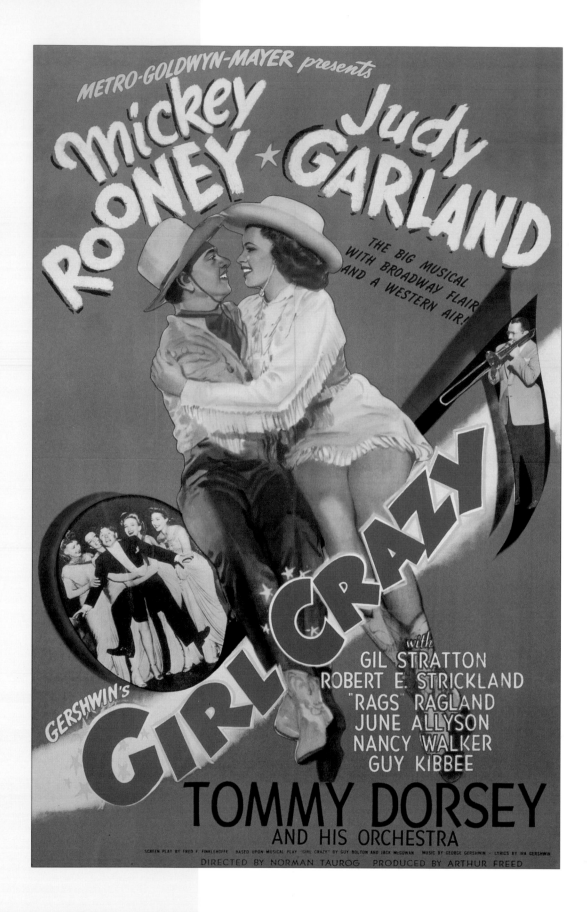

Girl Crazy
1943 MGM

The red-blooded son (Mickey Rooney) of a
newspaper publisher falls for the only girl
in sight (Judy Garland) at his boy's school.
When the school is threatened with closure,
the kids put on a show—complete with great
Gershwin tunes.

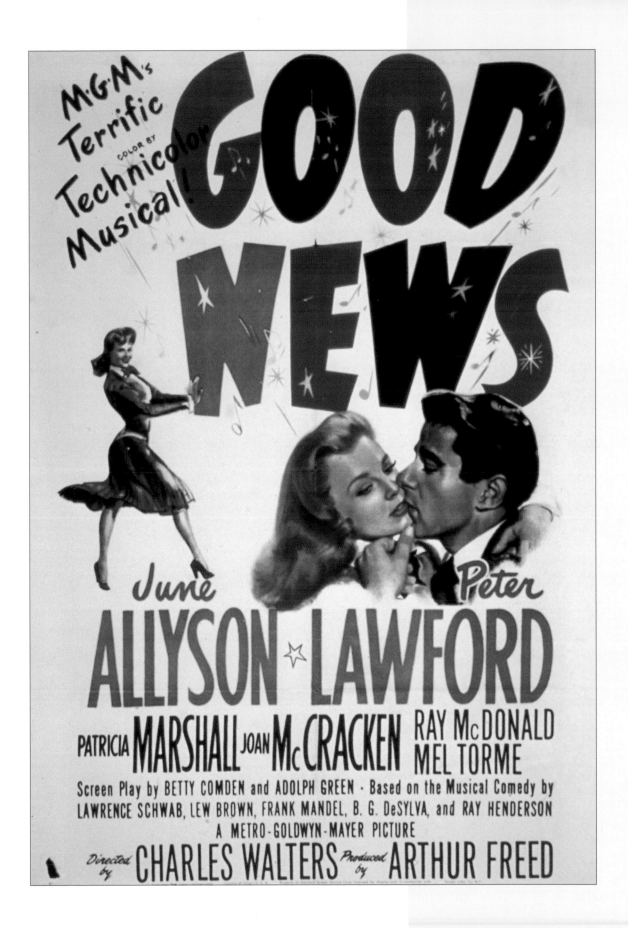

Good News
1947 MGM
A hunky college football star (Peter
Lawford) has trouble with his grades and
the campus sexpot (Patricia Marshall) until
a bubbly student librarian (June Allyson)
gives him a few private lessons.

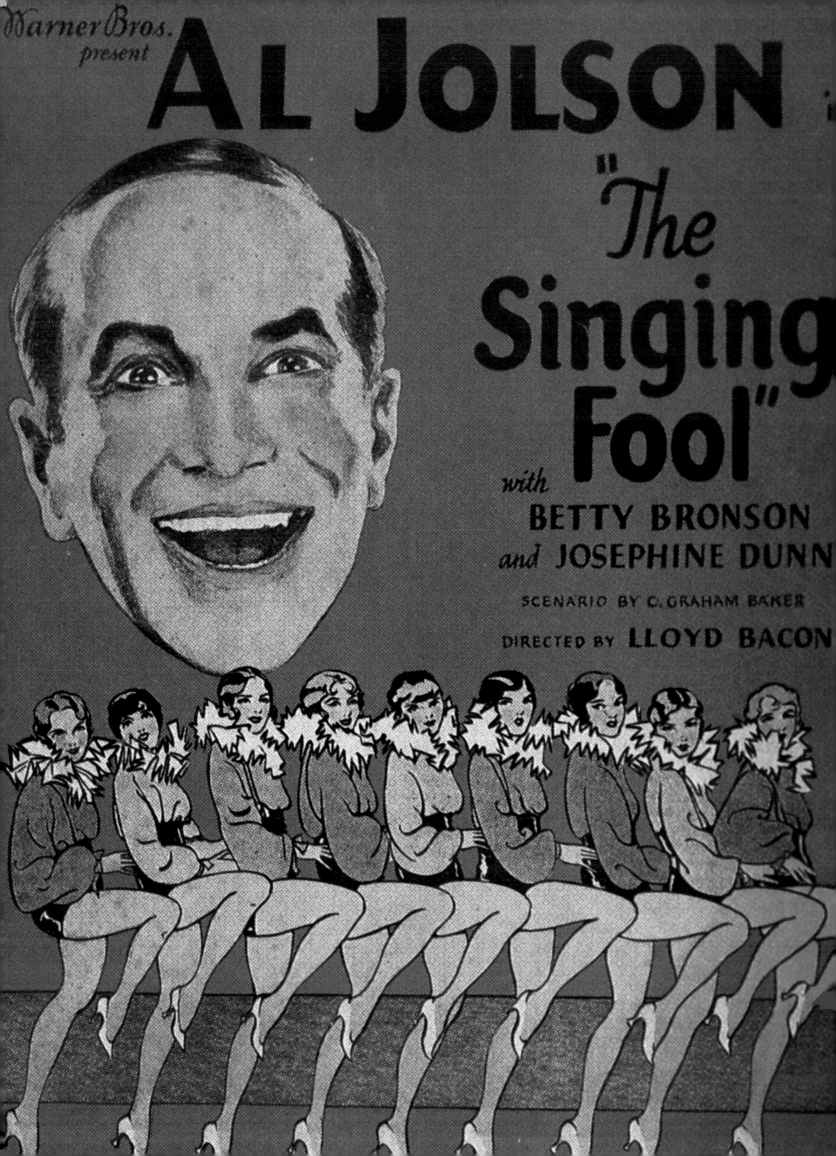

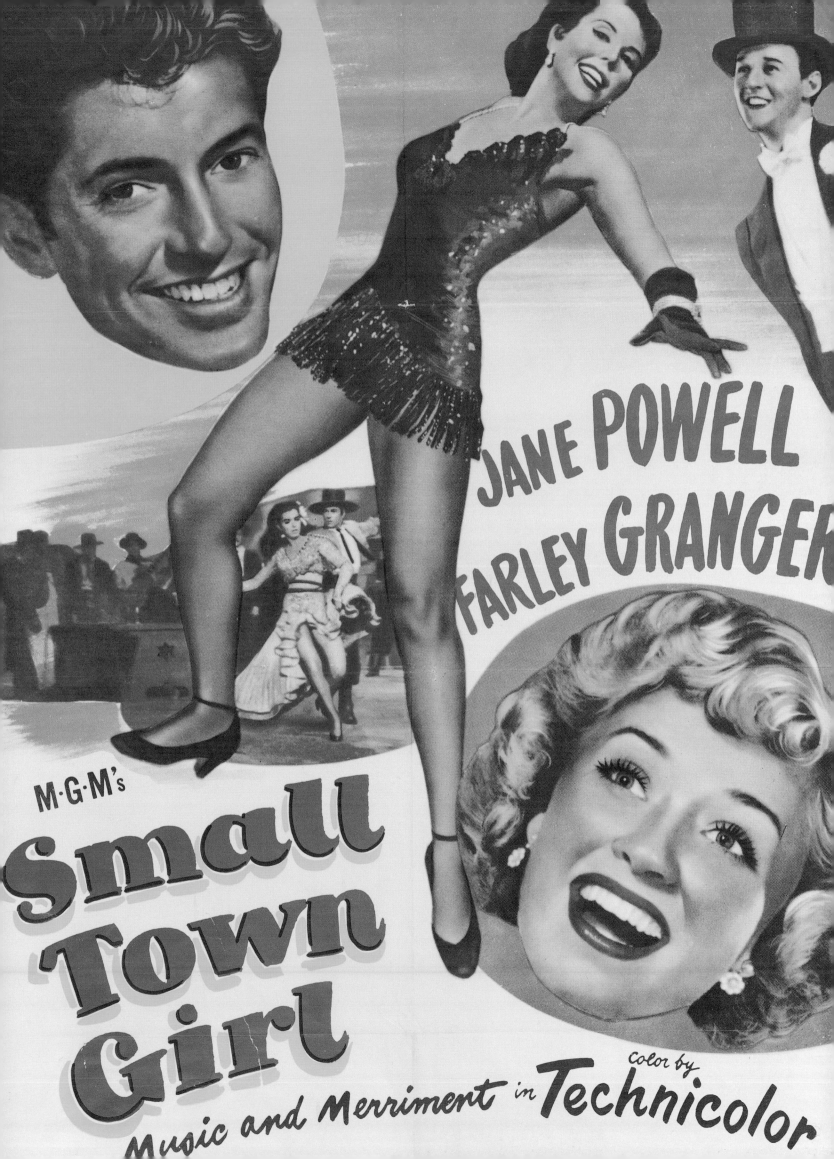

JANE POWELL

FARLEY GRANGER

M-G-M's

SMALL TOWN GIRL

Music and Merriment in color by Technicolor

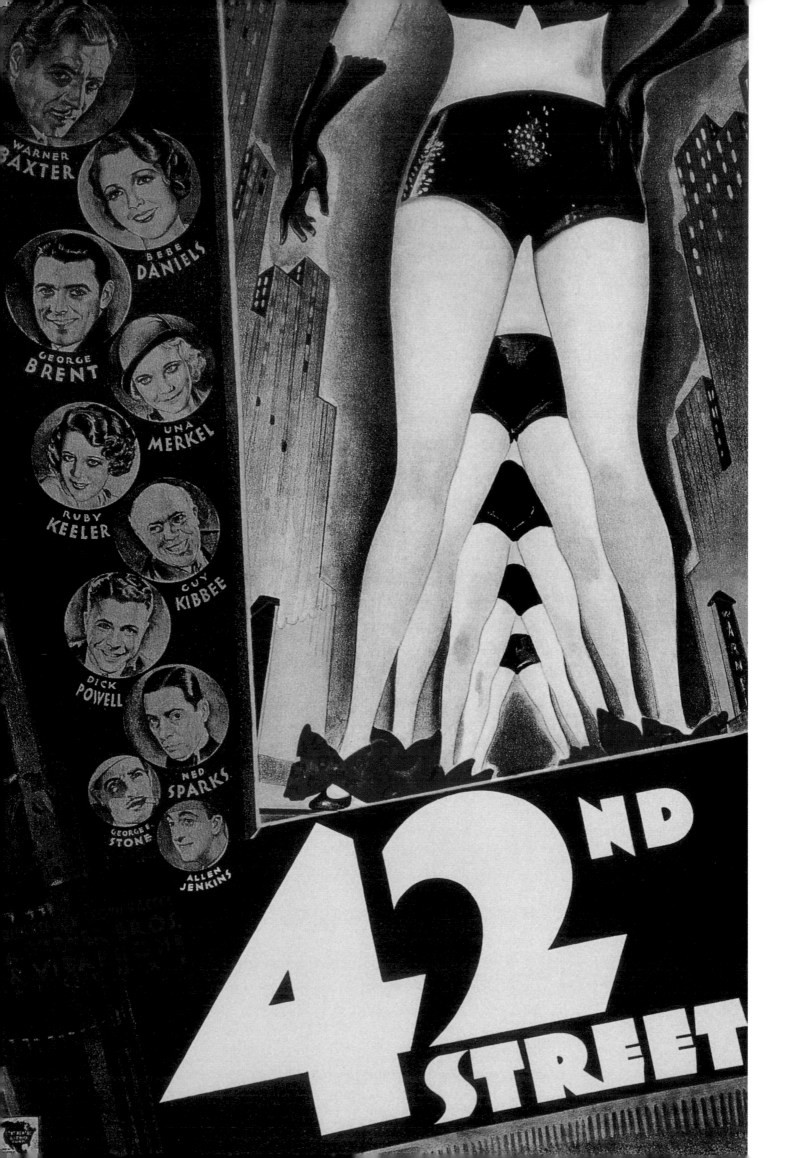

previous pages

The Singing Fool
1928 Warner Bros.

A waiter/songwriter (Al Jolson) loves the singer (Josephine Dunn) in his café in vain until the night he performs a song he wrote for her—and there's a Broadway producer in the crowd! The waiter waits no longer for fame or love.

Small Town Girl
1953 MGM

He's (Farley Granger) a millionaire playboy in the town slammer. She's (Jane Powell) the judge's daughter. Together with Busby Berkeley's direction, they make such beautiful music that he forgets his showgirl fiancée (Ann Miller).

42nd Street
1933 Warner Bros.

A Broadway director (Warner Baxter) wants to retire with a hit, but his farewell show takes a blow when the star (Bebe Daniels) breaks an ankle. Now the show depends on a chorus girl (Ruby Keeler) with spunk to spare.

Gold Diggers of 1933
1933 Warner Bros.

A blue-blooded songwriter (Dick Powell) backs a Broadway show to cozy up to the showgirl he loves (Ruby Keeler). His Beacon Hill brother (Warren William) first thinks she's after his money then falls for her roommate (Joan Blondell).

Presenting Lily Mars
1943 MGM

A sweet young girl from Indiana (Judy Garland) falls for a visiting Broadway producer (Van Heflin) and follows him to Broadway, hoping to get a part in his show. Eventually, she does—and makes it big.

Melody Cruise
1933 RKO

Two handsome young men (Charlie Ruggles/Phil Harris) take a steamship filled with marriage-minded lovelies to California where even the stewardess (Betty Grable) is beautiful. Romance develops between singing, dancing, and drinking champagne.

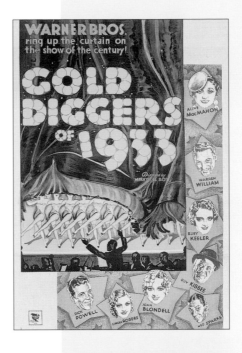

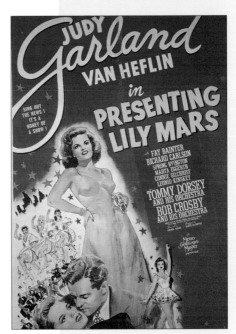

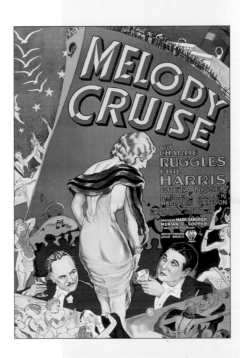

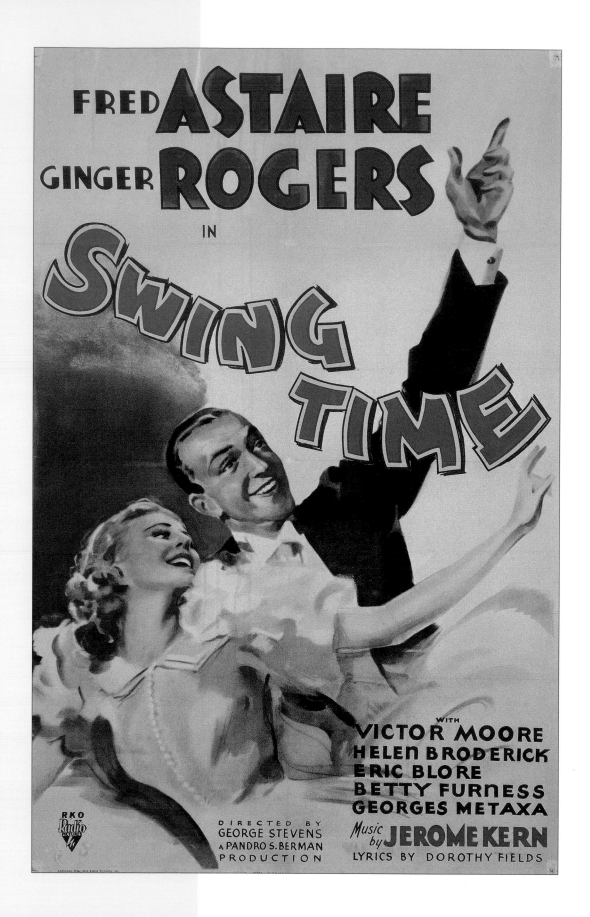

Swing Time
1936 RKO
A dancing dilettante (Fred Astaire) engaged to an heiress must earn $25,000 to marry her. Once he meets and falls for a beautiful dance instructor (Ginger Rogers), he works hard to stay broke.

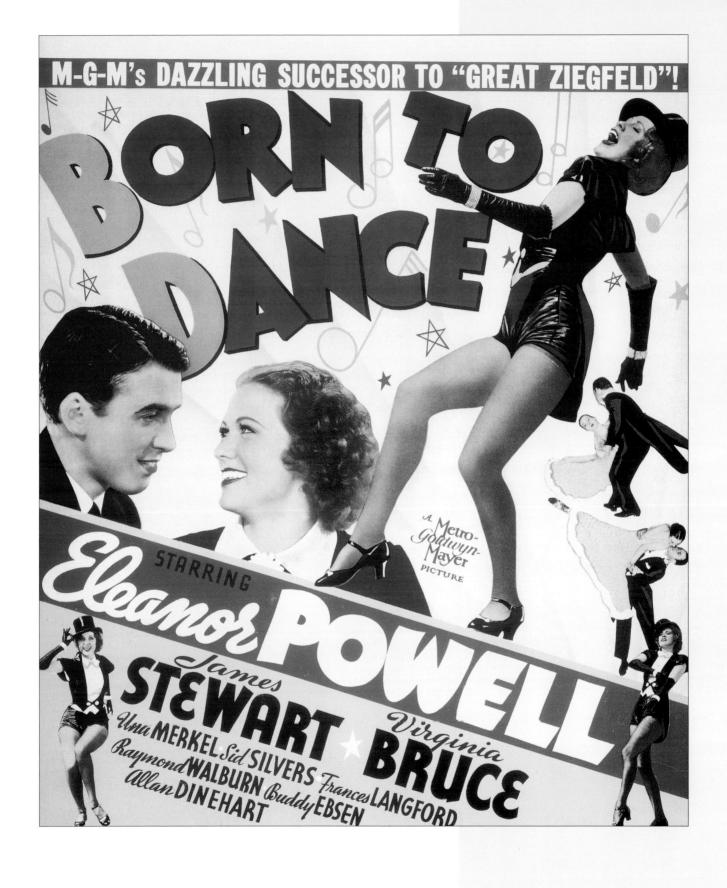

Born to Dance
1936 MGM
A shy boy (James Stewart) tries to hoof and croon his way into the heart of an accomplished dancer (Eleanor Powell). He eventually gets there, but more in spite of his singing than because of it.

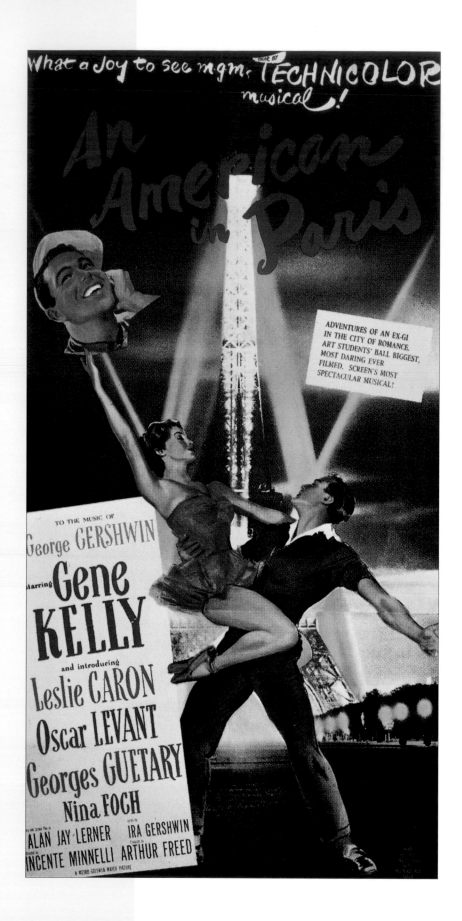

An American in Paris
1951 MGM
An American GI (Gene Kelly) stays in Paris
after the war to paint, resists becoming the
boy toy of a wealthy widow (Nina Foch), and
falls in love with his best friend's fiancée
(Leslie Caron).

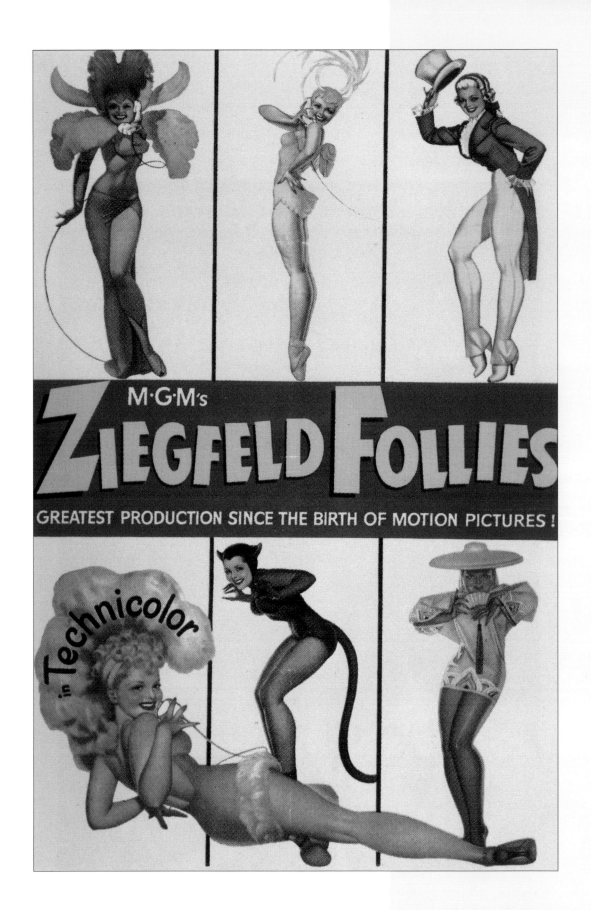

Ziegfeld Follies
1946 MGM

The late great Ziegfeld (William Powell)
dreams of putting on a show—in heaven.
The show goes on, with lavish production
numbers built around some of the greatest
stars on Earth: Fanny Brice, Judy Garland,
Fred Astaire, and Gene Kelly.

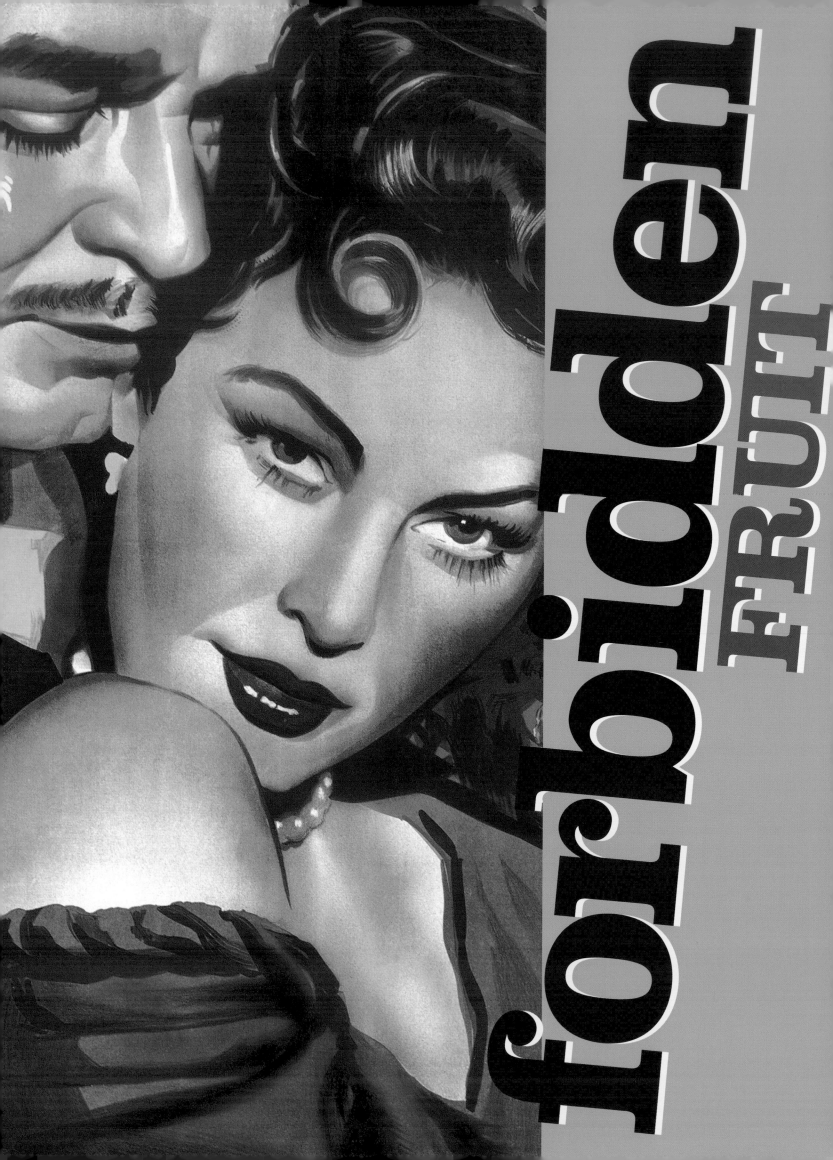

The Lure of the Apple.

Their eyes tell the story. One look at the torment there and we know that this romance is doomed before it ever begins. Doomed—and therefore utterly irresistible. Whether the obstacle is society, convention, or pesky old honor, a happy ending just isn't in the picture for some star-crossed couples. And they know it, too. But when love calls, who among us can refuse to answer? The story here is the old, familiar struggle between the conscience and the heart. Or perhaps the conflict resides a bit lower. Ultimately, though, whenever desire wrestles morality, somebody's in for heartbreak. Or worse.

How do you capture yearning in a poster? More often than not, with shimmering, romanticized portraits spotlighting the star's face so that the longing in his or her eyes was almost palpable up close. Before and after the Hays Code priggish reign (1934–60ish), posters were daring to the point of risqué with their trysting poses. Hays, however, insisted that all kissing be done upright and embracing be kept to a respectable angle.

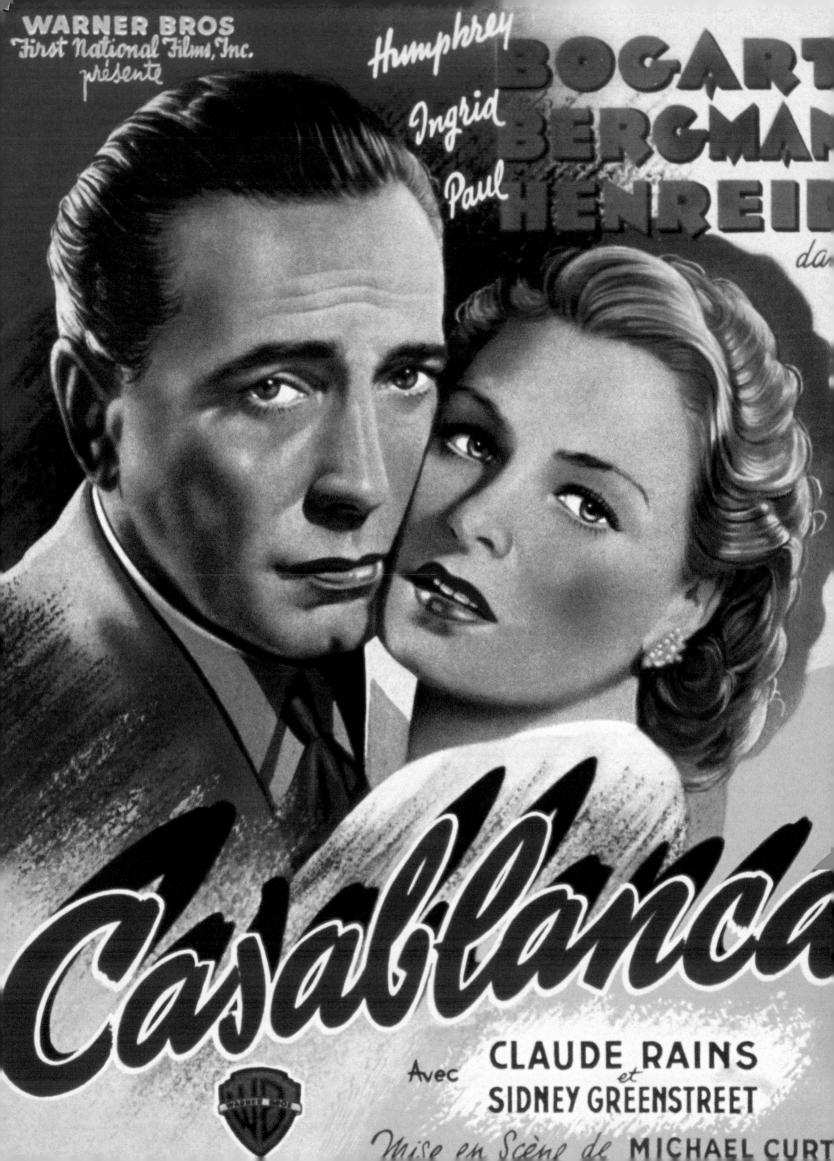

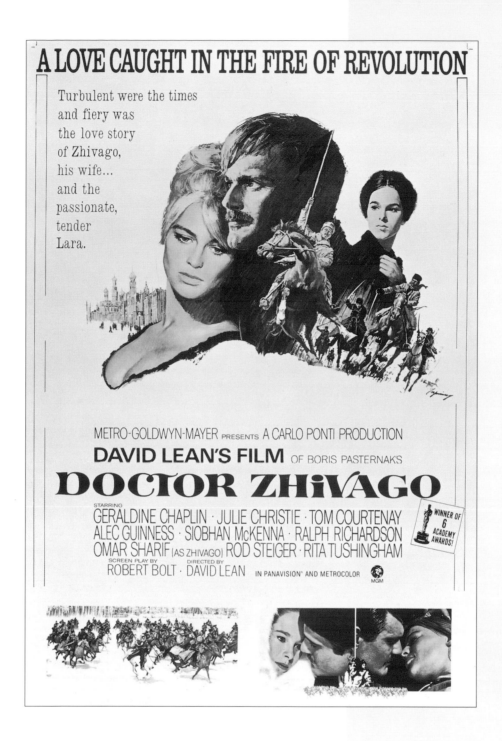

Casablanca
French
1942 Warner Bros.
Icon of Icons. THE love affair, THE song, and THE movie—no matter how much time goes by. Wartime lovers (Humphrey Bogart/Ingrid Bergman) are torn between love, honor, Nazis, and loyalty to her hero husband (Paul Henreid).

Doctor Zhivago
1965 MGM
The Bolshevik Revolution plays matchmaker when it takes a sensitive poet (Omar Sharif) from the arms of his wife (Geraldine Chaplin) and introduces him to the great love (Julie Christie) of his life.

BETTE DAVIS
PAUL HENREID

Now, Voyager

A HAL B. WALLIS PRODUCTION

CLAUDE RAINS

GLADYS COOPER · BONITA GRANVILLE · ILKA CHASE

Directed by IRVING RAPPER

SCREEN PLAY BY CASEY ROBINSON · FROM THE NOVEL BY OLIVE HIGGINS PROUTY · MUSIC BY MAX STEINER
A WARNER BROS. - FIRST NATIONAL PICTURE

Presented by

WARNER BROS

Vivien LEIGH · Robert TAYLOR

in WATERLOO BRIDGE

with

LUCILE WATSON
VIRGINIA FIELD
MARIA OUSPENSKAYA
C. AUBREY SMITH

A MERVYN LE ROY Production
SCREEN PLAY BY S. N. BEHRMAN, HANS RAMEAU AND GEORGE FROESCHEL
BASED ON THE PLAY "WATERLOO BRIDGE" BY ROBERT E. SHERWOOD

A METRO-GOLDWYN-MAYER
PICTURE

Directed by MERVYN LE ROY
Produced by SIDNEY FRANKLIN

HER *FIRST* PICTURE SINCE "GONE WITH THE WIND"

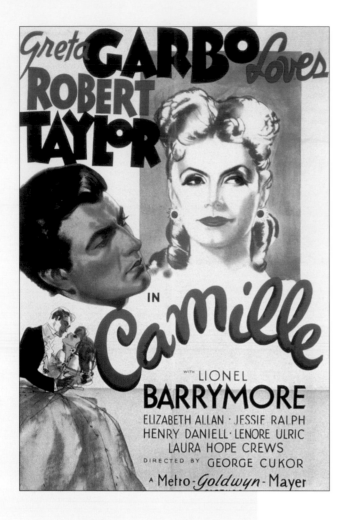

previous pages
Now, Voyager
1942 Warner Bros.

With the help of an unhappily—but permanently—married man (Paul Henreid), a wealthy ugly duckling (Bette Davis) transforms into a beautiful, self-sacrificing swan. The world's most romantic cigarette-lighting scene.

Waterloo Bridge
1940 MGM

A British ballerina (Vivien Leigh) starts walking the streets when she mistakenly thinks her aristocratic fiancé (Robert Taylor) is killed in World War I. She'd rather kill herself than hurt him with her past.

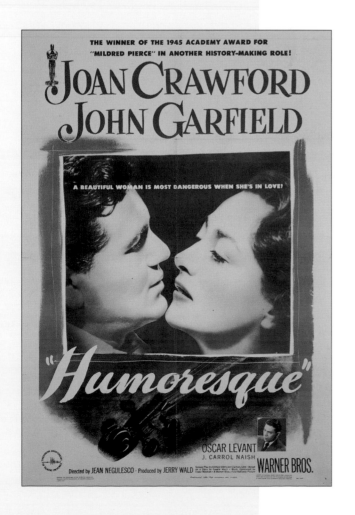

Camille
1936 MGM

World-weary Parisian courtesan (Greta Garbo) chooses to ruin her own life and die in poverty of consumption rather than ruin the life of the innocent young aristocrat (Robert Taylor) who loves her.

Humoresque
1946 Warner Bros.

A society dilettante (Joan Crawford) in a loveless marriage is drawn to her poor protégé, a violin virtuoso (John Garfield) who can't be bought. Is the other woman a violin—or his mother?

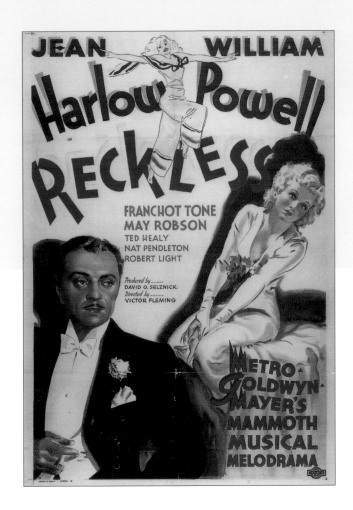

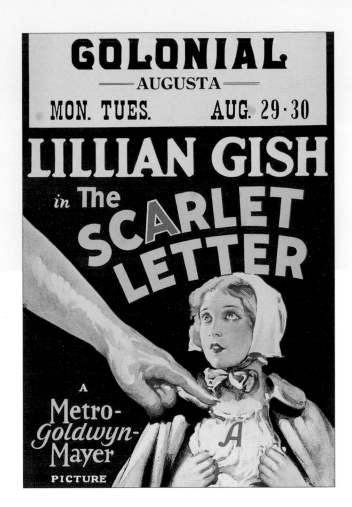

Reckless
1935 MGM
A Broadway star (Jean Harlow) seeks comfort from her agent (William Powell) when her husband dallies with his old flame. When her husband commits suicide in response, the star and her agent take the fall.

The Scarlet Letter
1926 MGM
Puritan maiden Hester (Lillian Gish) earns an "A" for adultery when she goes dancing in the sheets with the local clergy and begets a little Pearl. Proof that sin, like crime, never pays.

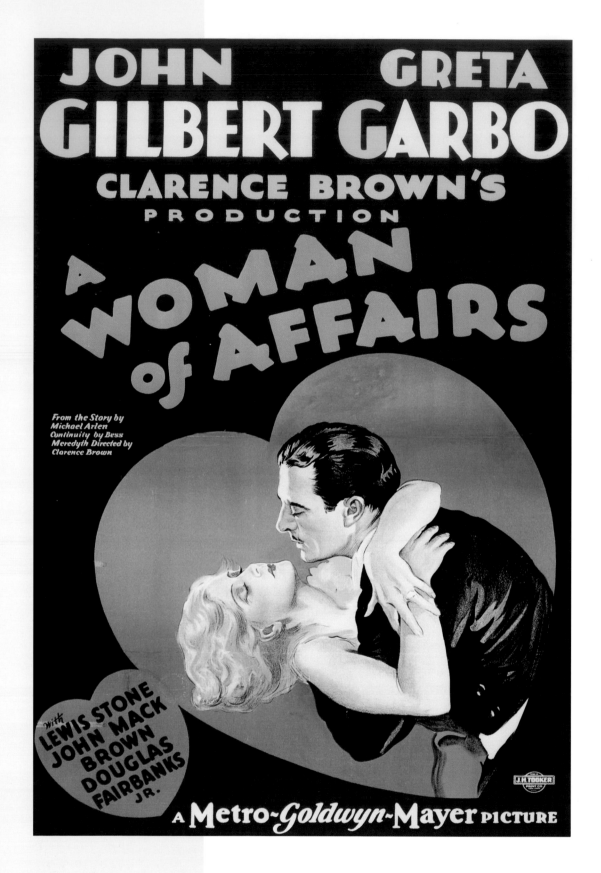

A Woman of Affairs
1928 MGM

A free-spirited beauty (Greta Garbo) from a reckless aristocratic family falls for an innocent young man (John Gilbert) whose conservative father stops their marriage. Ruin and redemption follow.

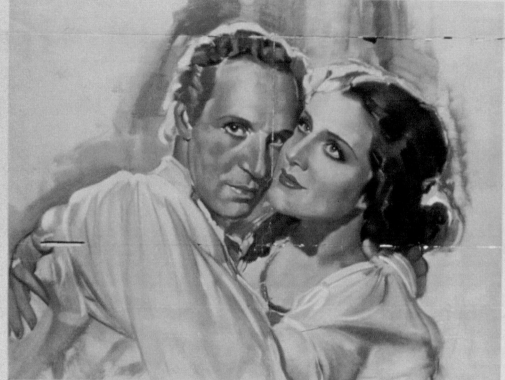

Romeo and Juliet
1936 MGM

Too much love, too little time. Lavish and
stylish production of an immortal tale of
woe. Never have there been older stars play-
ing the fair Juliet (Norma Shearer) and her
Romeo (Leslie Howard).

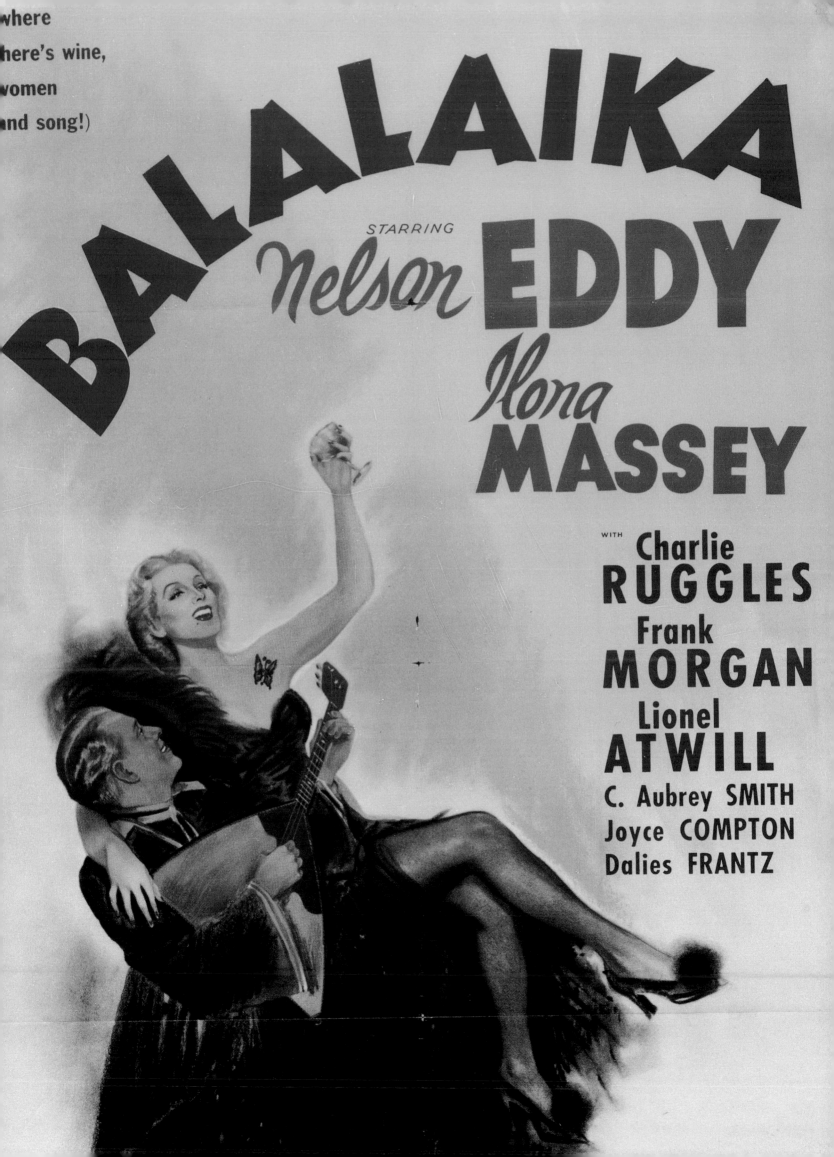

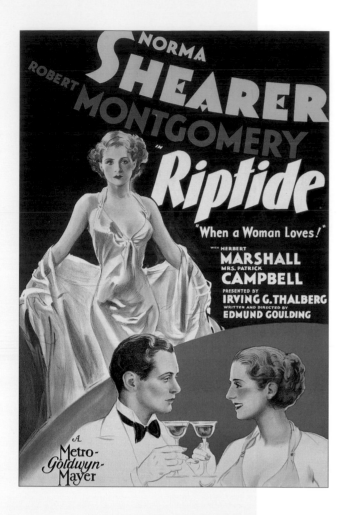

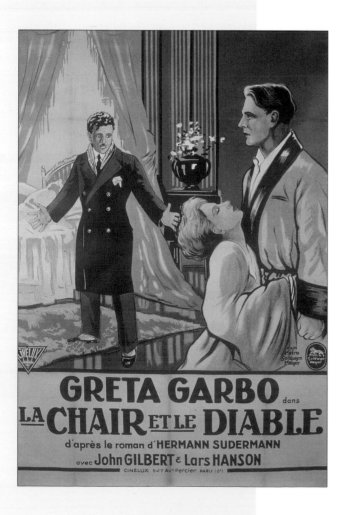

previous pages
King Kong
1933 RKO
A giant gorilla (King Kong) loses his heart to an exotic blonde (Fay Wray) and it costs him his life. The first and ultimate beauty and the beast story to hit the screen.

Balalaika
1939 MGM
A Russian Prince (Nelson Eddy) arranges for the daughter (Ilona Massey) of a Bolshevik to sing at the Imperial Opera. Her father assassinates his father on that very night. They both sing beautifully and often.

Riptide
1934 MGM
A free-spirited American "It" girl (Norma Shearer) weds an English lord after a whirlwind romance. Years later, an "It" scandal threatens their happy manor when an old flame's (Robert Montgomery) drunken advances make headlines.

Flesh and the Devil (La Chair et le Diable)
French
1926 MGM
A soldier is sent to Africa after he kills his lover's (Greta Garbo) husband in a duel. He asks his best friend (John Gilbert) to watch over the seductive countess while he's away. Duel number two, coming up.

Wife Versus Secretary
1936 MGM
Beautiful, beloved wife (Myrna Loy) dons boxing gloves when she suspects her husband (Clark Gable) of going extra rounds with his knockout—but nice—secretary (Jean Harlow) in sultry Havana.

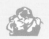

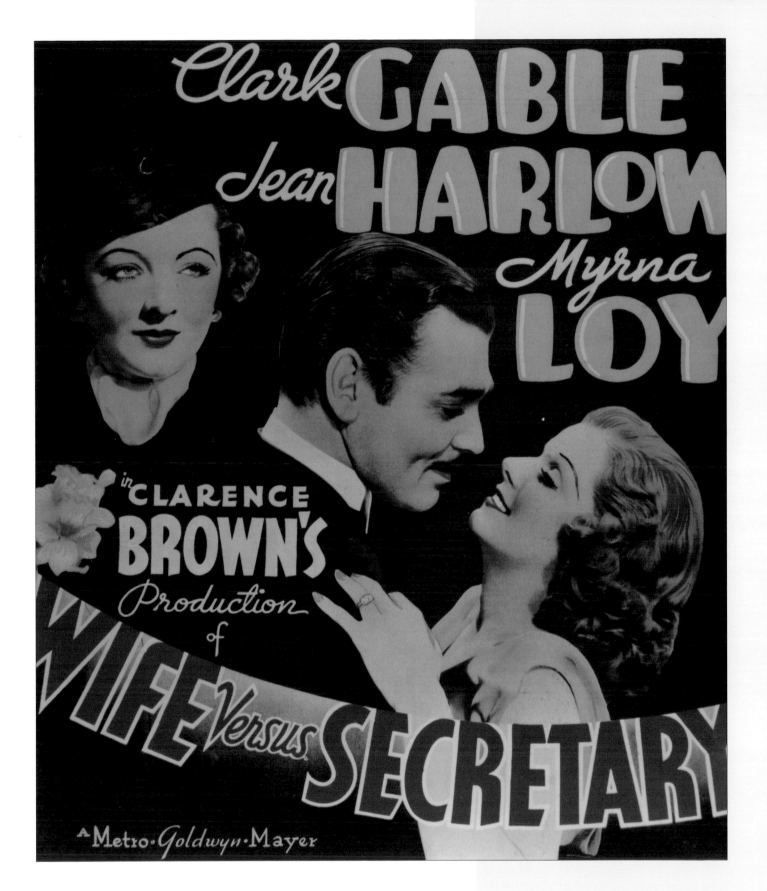

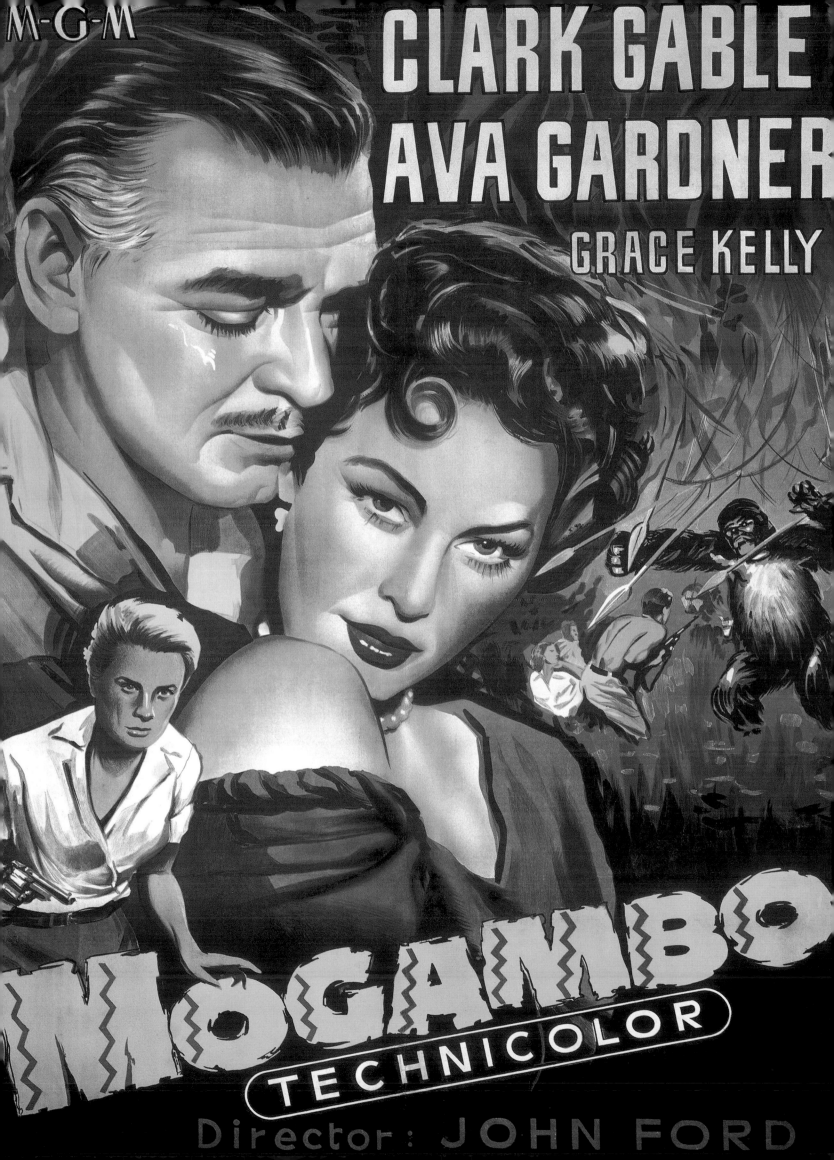

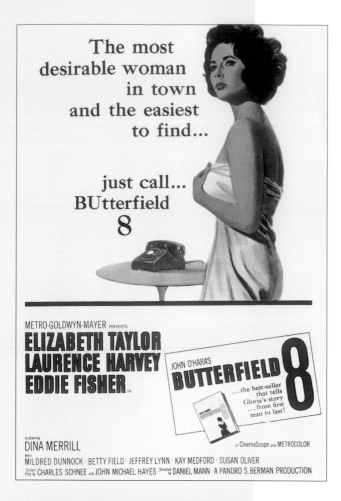

previous pages

Red Dust
1932 MGM
The rough-and-tumble overseer of an Asian rubber plantation (Clark Gable) meets his match in a feisty prostitute (Jean Harlow) but thinks his soul mate is the prim, elegant wife (Mary Astor) of his new surveyor.

Mogambo
1953 MGM
Red Dust, redux. A world-weary safari leader (Clark Gable) falls for a cool beauty (Grace Kelly) studying gorillas with her nebbish husband instead of the gorgeous ex-flame showgirl (Ava Gardner) who turns up by accident.

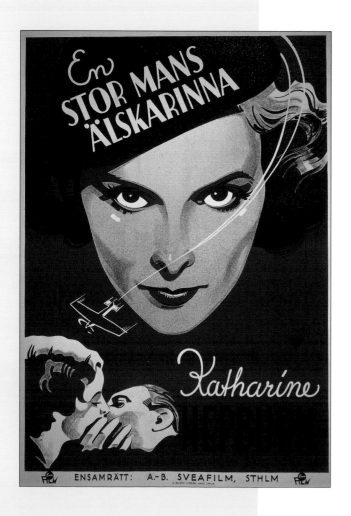

Butterfield 8
1960 MGM
Gloria (Elizabeth Taylor) is a call girl who calls the shots in her relationships. When she thinks Mr. Almost Right (Laurence Harvey) won't leave his wife, she makes the ultimate call.

Christopher Strong (En Stor Mans Alskarinna)
Swedish (Translation: A Great Man's Mistress)
1933 RKO
A high-spirited aviatrix (Katharine Hepburn) has no time for love until she meets a happily married man who cranks her engine. Love takes flight and a child is conceived. Honor demands her death.

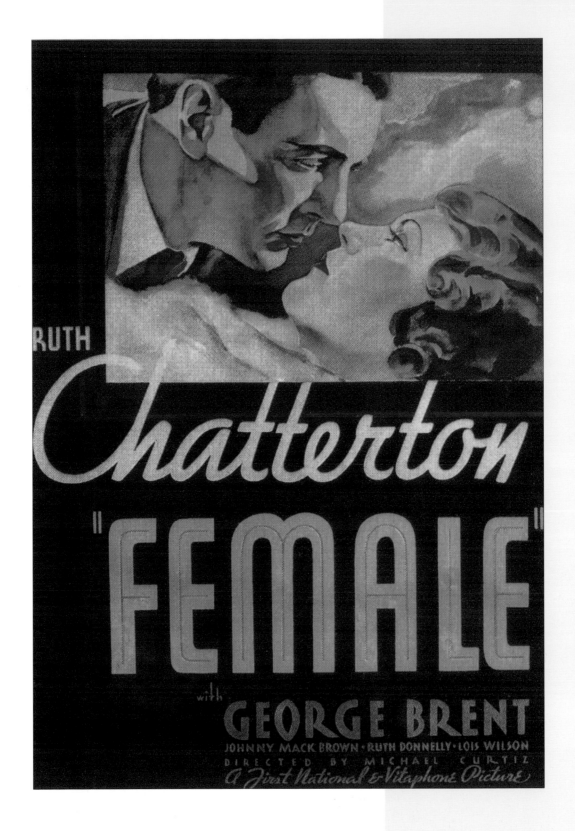

Female
1933 Warner Bros.

The female owner of an automobile factory (Ruth Chatterton) likes to tinker with her mechanics. The right man (George Brent) teaches her a lesson, and she makes him the boss. Chauvinistic filmmaking at its best.

forward MARCH

Flyboys, Doughboys, and Sailors. Oh My!

Hollywood makes war movies for the same reason a poem about a warrior named Beowulf has lasted 1500 years: Everybody loves a hero—especially one in uniform. With one terrible war behind her and another breaking her heart, America needed a little flag waving to remind her what she stood for—and against. Hollywood did its part with movies that were alternately brutal and real or naïve escapist fare sweet enough to make your teeth ache. The common thread is the most old-fashioned love of all: love of country.

The more realistic the movie, the more likely its poster was to feature inspirational portraiture of its star looking heavenward with a wistful, I-see-my-destiny-over-that-next-ridge look in his eyes. Vignettes depicting heroic action and thundering prose painted pictures of men who faced death every day, without ever losing their love of life. Wartime musicals with their jaunty titling were the cinematic equivalent of the USO: a lighthearted moment in the long, dark night of war.

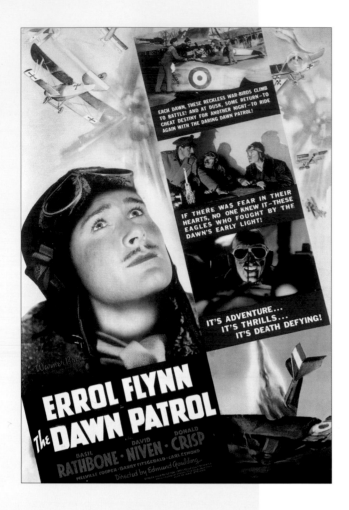

The Dawn Patrol
1938 Warner Bros.

Every morning they climb into rickety planes and face the Germans. And every morning, some of them die. A new commander (Errol Flynn) learns sending men in harm's way is the hardest job in the world.

The Bugle Sounds
1941 MGM

An old-fashioned cavalryman (Wallace Beery) encounters sabotage and stubborn soldiers as the old army evolves to a new, "horseless" army with cumbersome iron beasts called "tanks."

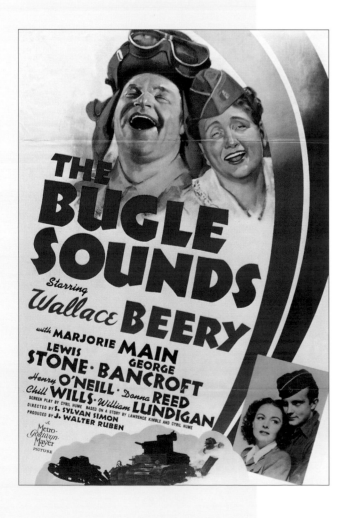

following pages

Back to Bataan
1945 RKO

The fall and rescue of Bataan as seen through the eyes of an American colonel (John Wayne) commanding Filipino scouts and his second in command (Anthony Quinn), who survives the Bataan Death March.

The Dirty Dozen
1967 MGM

Twelve murderers, rapists, and thieves looking at life (or death) in military prison volunteer for a suicide mission to blow up a chateau filled with Nazi brass hidden deep in occupied France.

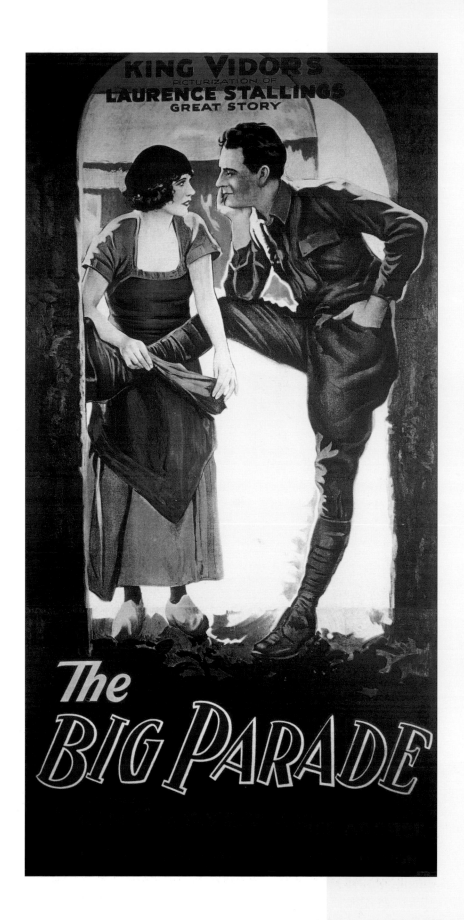

The Big Parade
1925 MGM

Silent film that speaks volumes about the
hell of war as it follows a soft, spoiled
young man (John Gilbert) who is neither
soft nor young by the war's end.

TRAIN THEM! EXCITE THEM! ARM THEM!

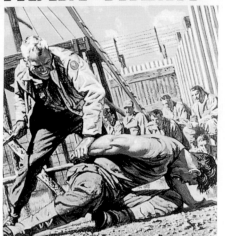 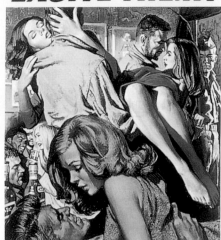 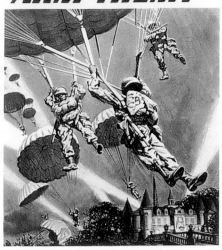

...THEN TURN THEM LOOSE ON THE NAZIS!

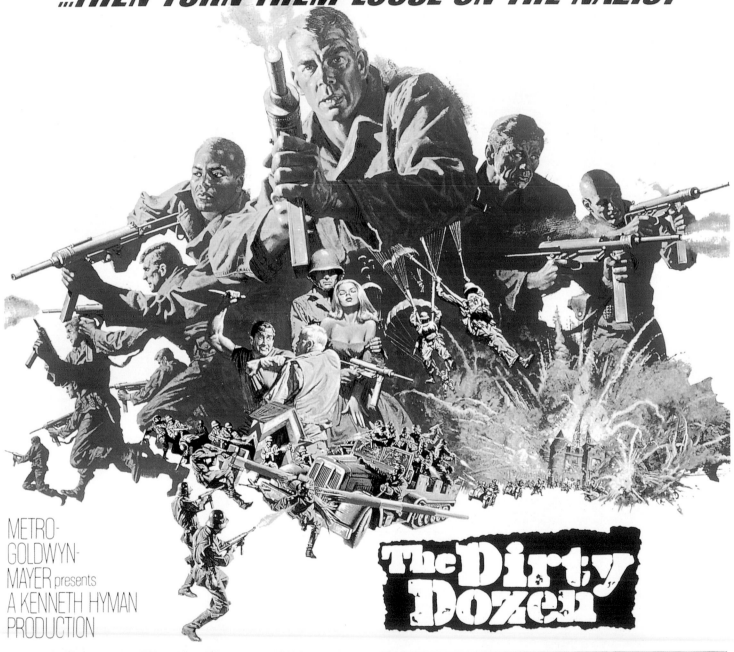

METRO-GOLDWYN-MAYER presents A KENNETH HYMAN PRODUCTION

The Dirty Dozen

Starring LEE **MARVIN** ERNEST **BORGNINE** CHARLES **BRONSON** JIM **BROWN** JOHN **CASSAVETES** RICHARD **JAECKEL**

GEORGE **KENNEDY** TRINI **LOPEZ** RALPH **MEEKER** ROBERT **RYAN** TELLY **SAVALAS** CLINT **WALKER** ROBERT **WEBBER**

screenplay by NUNNALLY JOHNSON and LUKAS HELLER From the novel by E M NATHANSON Produced by KENNETH HYMAN Directed by ROBERT ALDRICH IN METROCOLOR 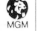 MGM

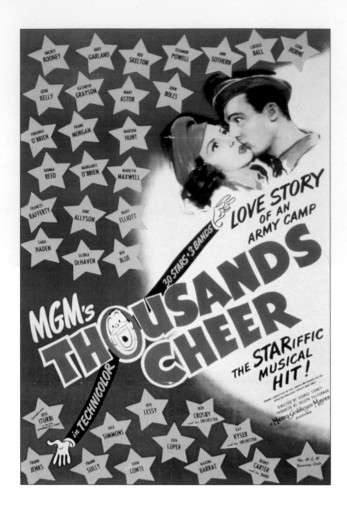

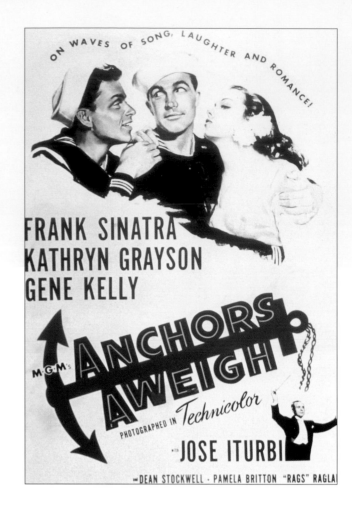

Thousands Cheer
1943 MGM

This plot—trapeze artist (Gene Kelly) meets opera singer (Kathryn Grayson) via Uncle Sam—is just an excuse to put "more stars than there are in heaven" in one spectacular flag-waving good time.

Anchors Aweigh
1945 MGM

Singing, dancing, and romancing sailors (Frank Sinatra/Gene Kelly) turn a shore leave in Hollywood into a sure thing by promising beautiful girls auditions they really can't deliver.

Follow the Fleet
1936 RKO

There's dancing, dancing, and more dancing when Bake and Bilge (Fred Astaire/Randolph Scott) hit the Paradise Club on shore leave and run into the dancing partner who broke Bake's heart back in the States.

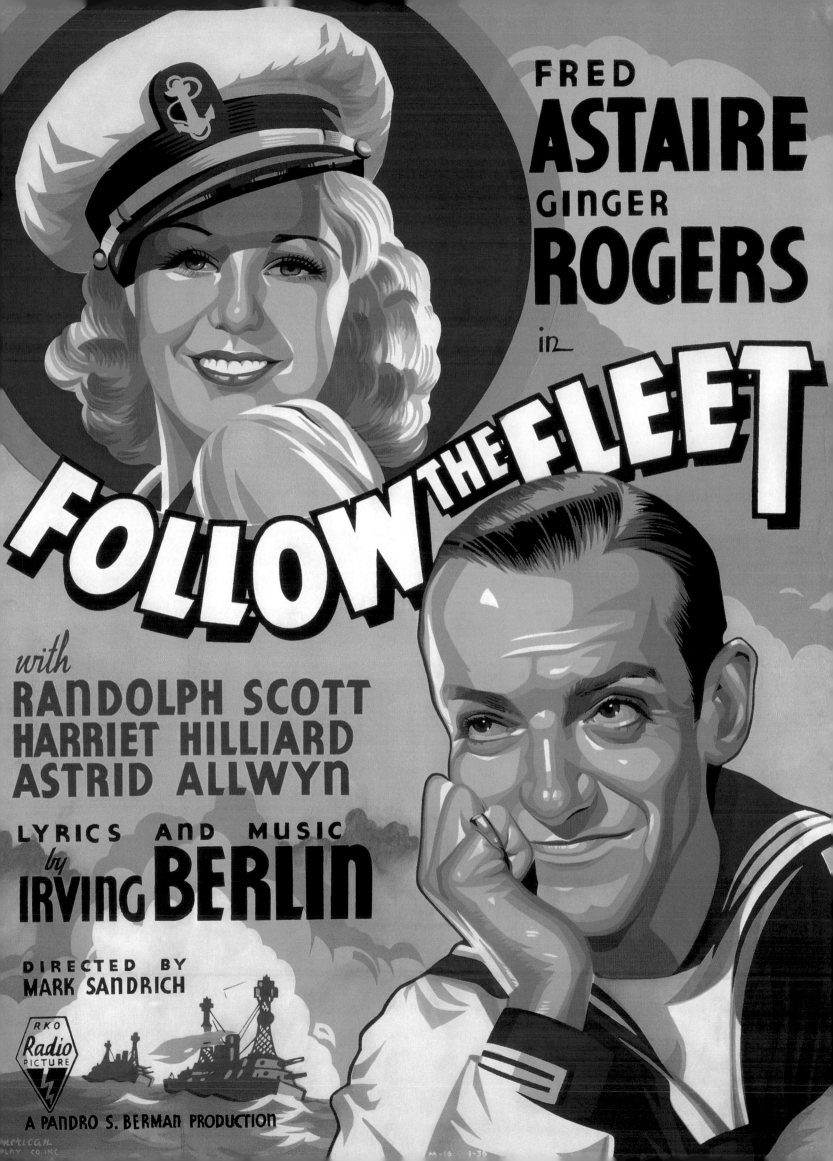

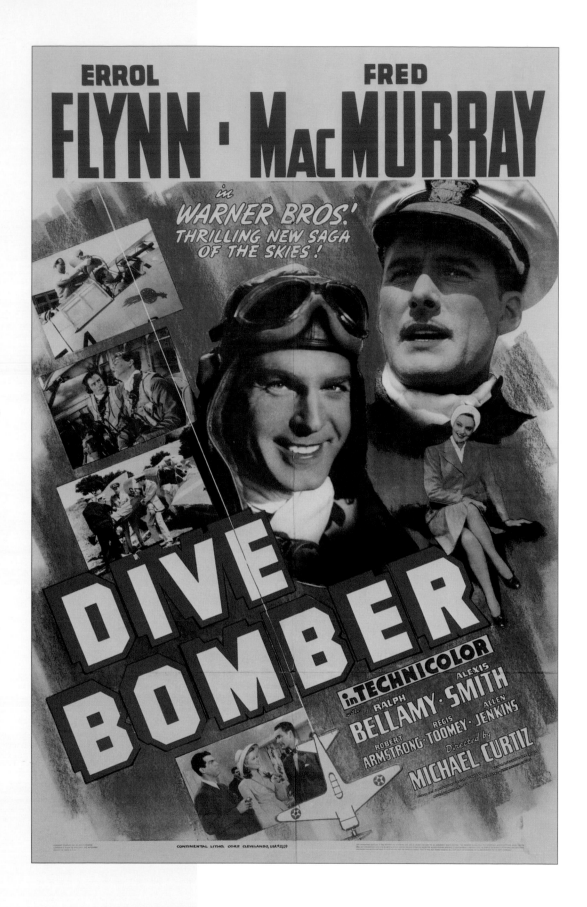

Dive Bomber
1941 Warner Bros.
When a pilot faints during a high altitude dive and dies under his knife, a flight surgeon (Errol Flynn) makes it his mission to find out why—and invents a flight suit to prevent it from ever happening again.

International Squadron
1941 Warner Bros.

A stunt pilot (Ronald Reagan) delivering bombers to the RAF changes his cavalier ways and flies to his death after he sleeps through a patrol mission and his substitute pilot is killed.

Pride of the Marines
1945 Warner Bros.

He took out 200 enemy soldiers on Guadalcanal, many of them after he was blinded. Now Al Schmidt (John Garfield) must find the courage to face his bride—and his life—in the dark.

following pages

Sergeant York
1941 Warner Bros.

Tennessee sharpshooter Alvin C. York (Gary Cooper) was a shy, religious man who struggled with the morality of war. He also captured 132 Germans single-handedly at Argonne in WWI—and the admiration of his whole country.

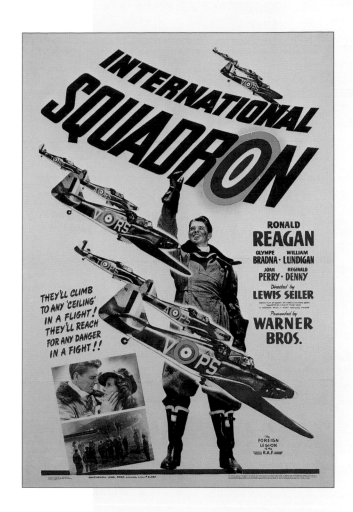

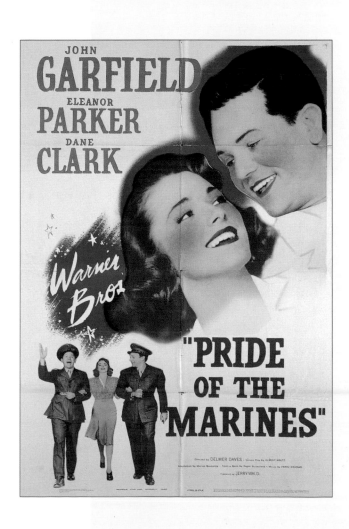

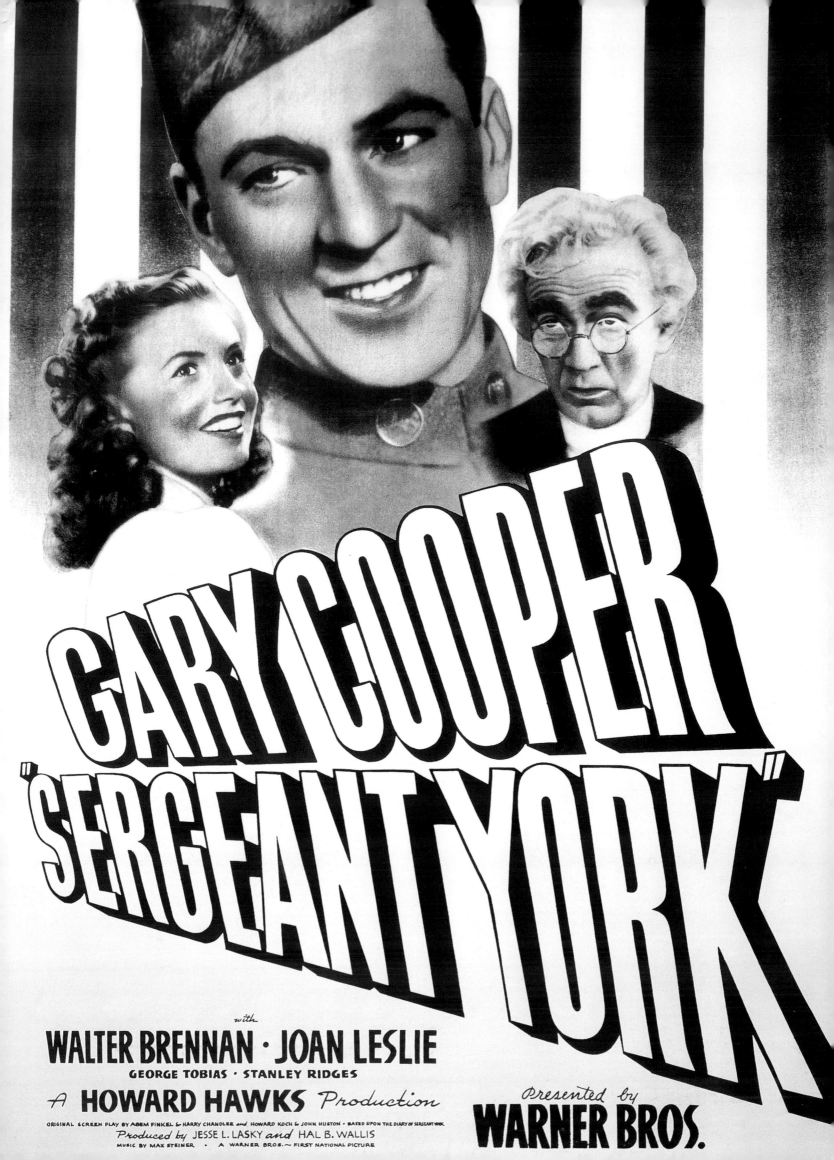

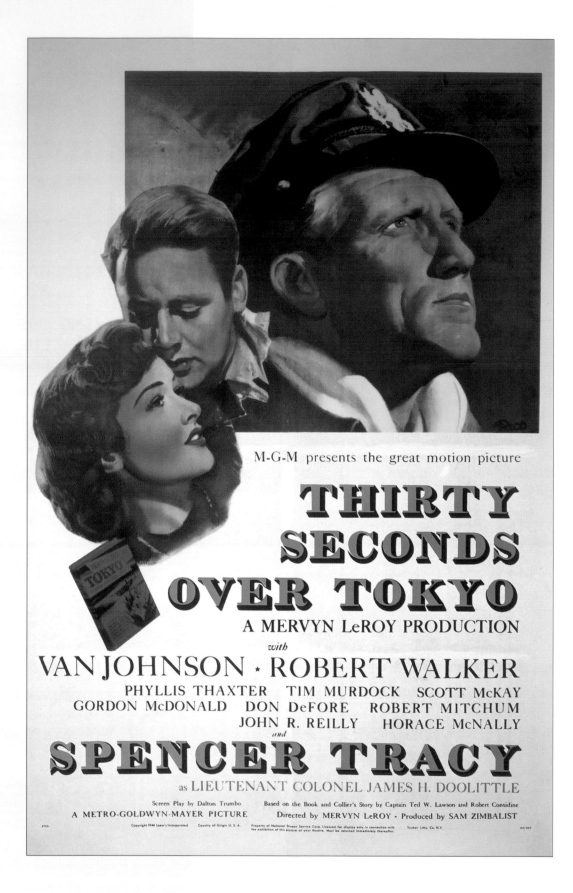

Thirty Seconds over Tokyo
1944 MGM

Three months after Pearl Harbor, Lt. Col. James Doolittle (Spencer Tracy) led a top-secret American retaliation mission that launched from the deck of an aircraft carrier. The dangerous return plan? Land in enemy-occupied China.

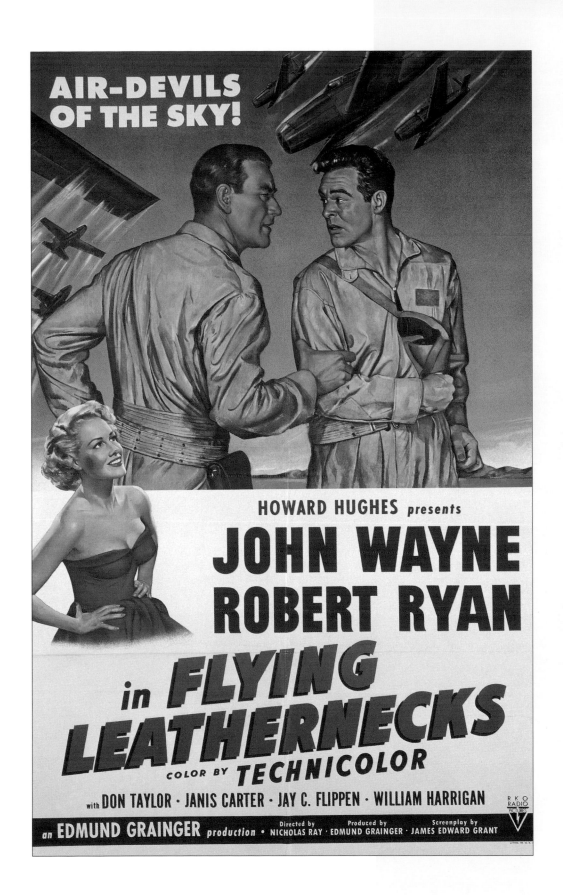

Flying Leathernecks
1951 RKO
The major's (John Wayne) men are
exhausted and their airplanes are shot
full of holes. But there's a war up there
at 10,000 feet that only they can fight.
Does he send them back up?

GUN-slingers

Roam, Roam on the Range.

The American West was a big canvas, the biggest one this country ever had. Everything about it was big—including the people who settled it. Telling a good man from a bad one was as easy as checking the color of his hat. Telling good women from bad was easier still: apron = good, saloon = bad. Shoot-outs, Indian attacks, rattlesnakes, and heartbreak were all in a day's work on the range. But when the sun went down, all a cowboy really had was the love of a good horse.

Turning the feverish action of a Western into a good poster meant marrying three things: a ten-gallon hat, a pair of blazing six-guns, and at least one horse—though a stampeding herd was better. When the star was more important than the particular movie, the star's name would be lettered more elaborately (and larger) than the title. And in hopes of attracting women audiences to a "horse opera," even the most minor love interest was highlighted in a vignette.

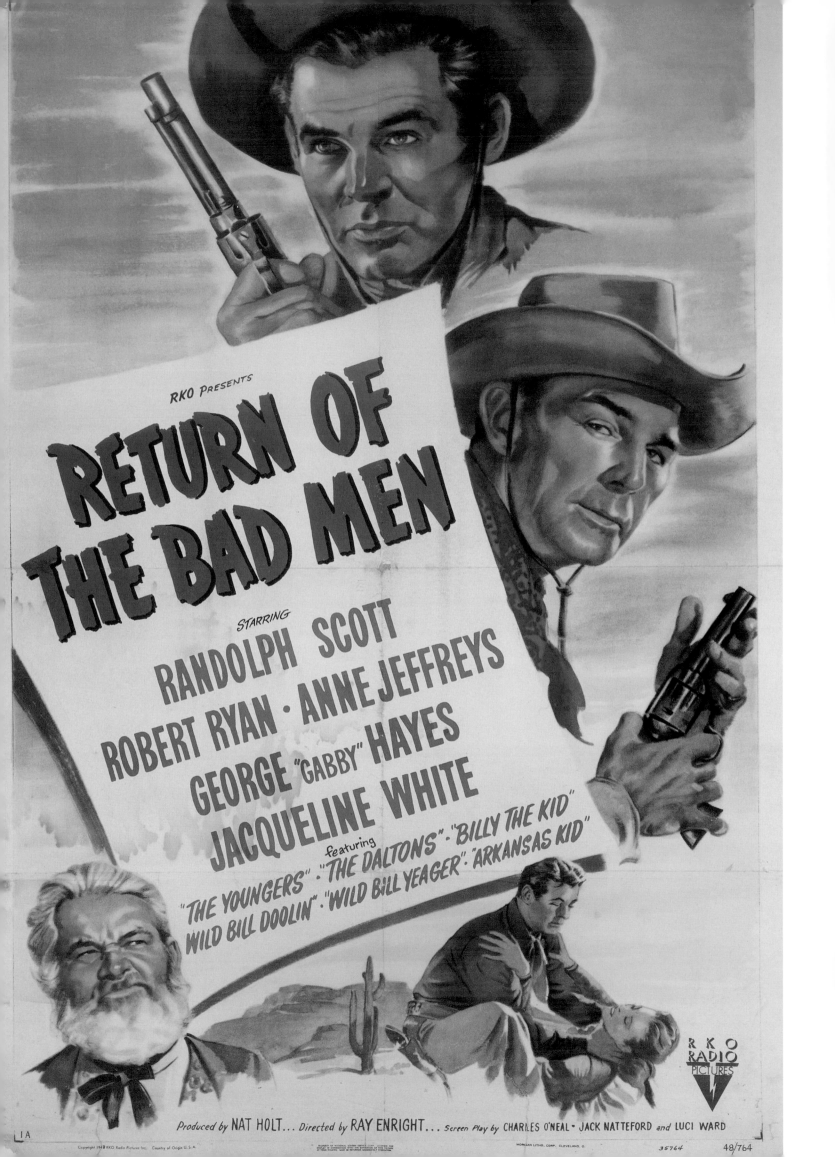

Return of the Bad Men
1948 RKO

The Sundance Kid (Robert Ryan) leads an
all-star outlaw gang on a rampage of hold-
ups and hijinks. Only one man can handle
them—a marshall (Randolph Scott) who put
down his guns years ago.

The Sheepman
1958 MGM

An enraged sheep rancher (Glenn Ford) who
drinks milk takes on the town cattle baron
and exposes the cowman's shady past as a
gunslinger. The rancher wins the girl
(Shirley MacLaine) and the gunfight.

The Big Stampede
1932 Warner Bros.

The line between good and bad gets
blurry when a new sheriff (John Wayne)
plays both sides to get the job done. The
rustler (Noah Berry) who killed the old
sheriff scowls ferociously.

following pages

The Searchers *(La Prisonnière Du Désert)*
French (Translation: The Prisoner of the Desert)
1956 Warner Bros.

Ex-soldier (John Wayne) spends years pur-
suing the Comanches who killed his family
and stole his niece—intending to kill the
girl (Natalie Wood) when he finds her.
Iconic tale of race and redemption.

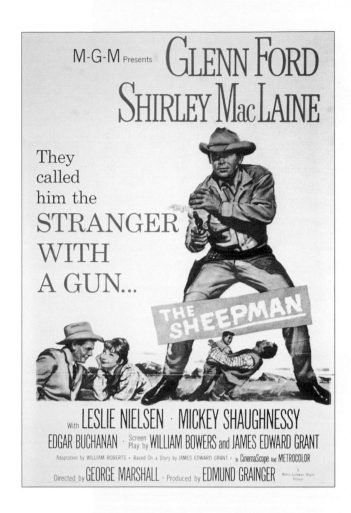

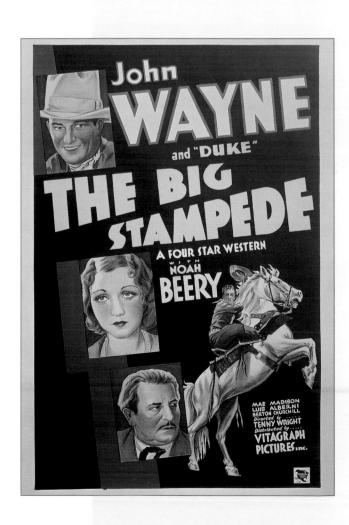

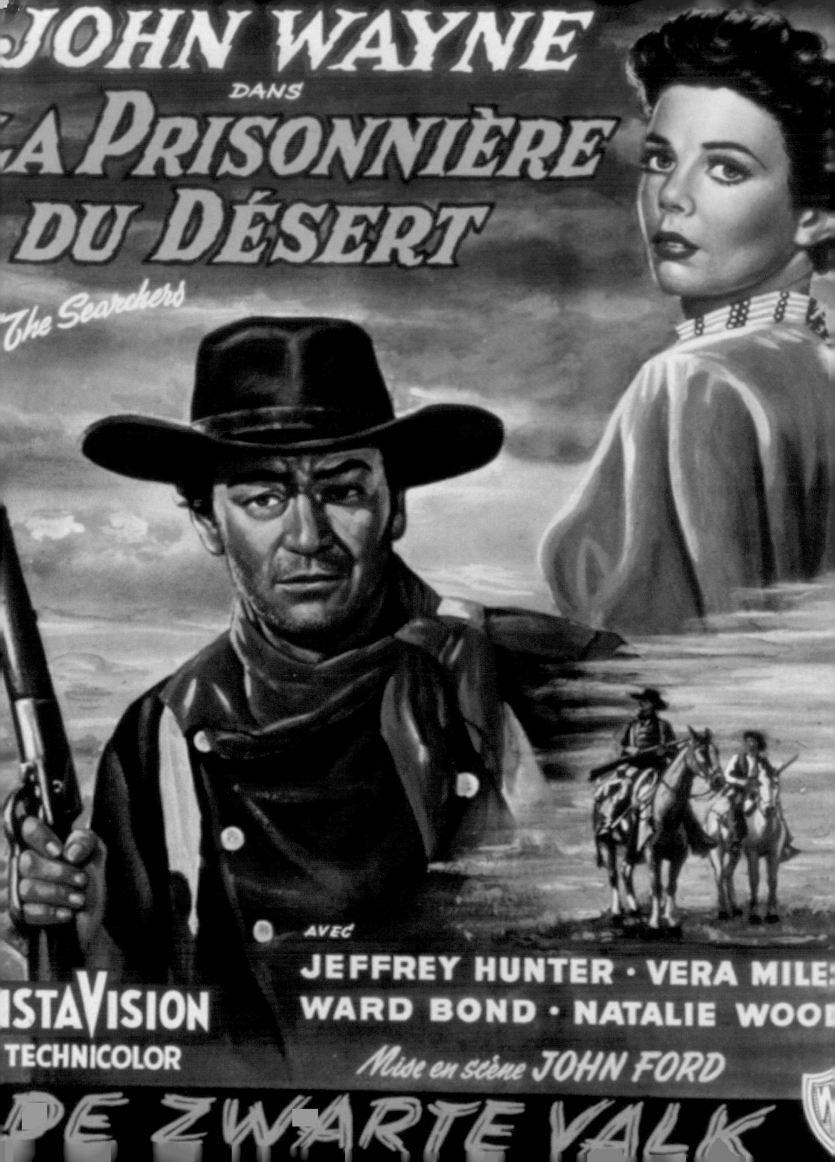

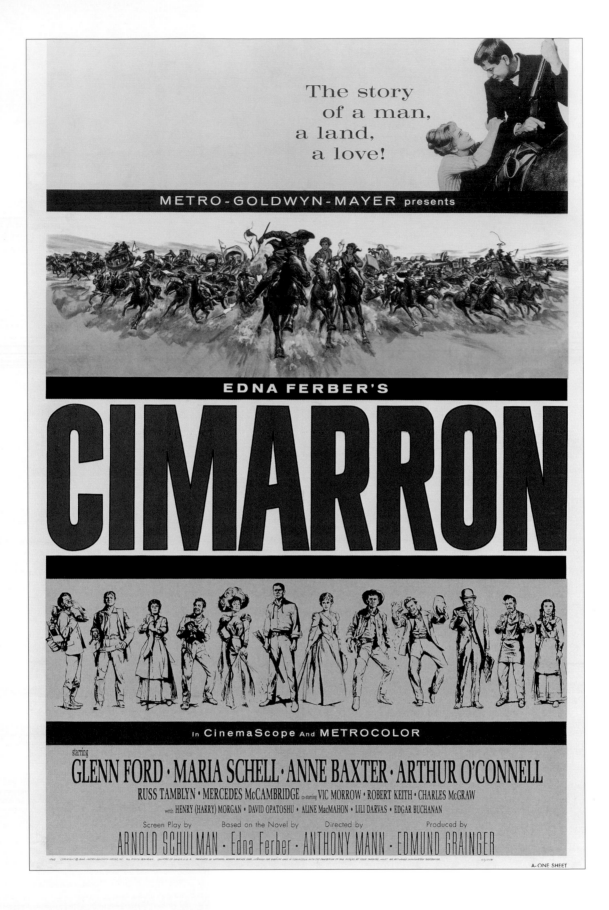

Cimarron
1960 MGM
The Oklahoma land rush inspires a life-long case of wanderlust for a man (Glenn Ford) who just can't say no to adventure. His wife (Maria Schell) runs a newspaper and goes to Congress.

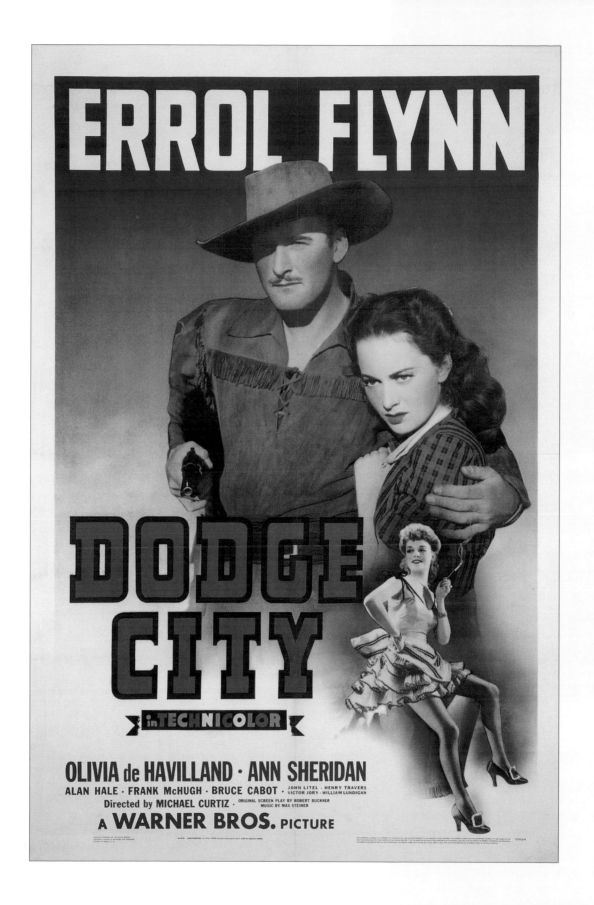

Dodge City
1939 Warner Bros.
Adventurer Wade Hatton (Errol Flynn) has
to survive gunfights and treachery before
taming this wild town. He's distracted by
lust (Ann Sheridan), but true love (Olivia de
Havilland) and lawfulness prevail.

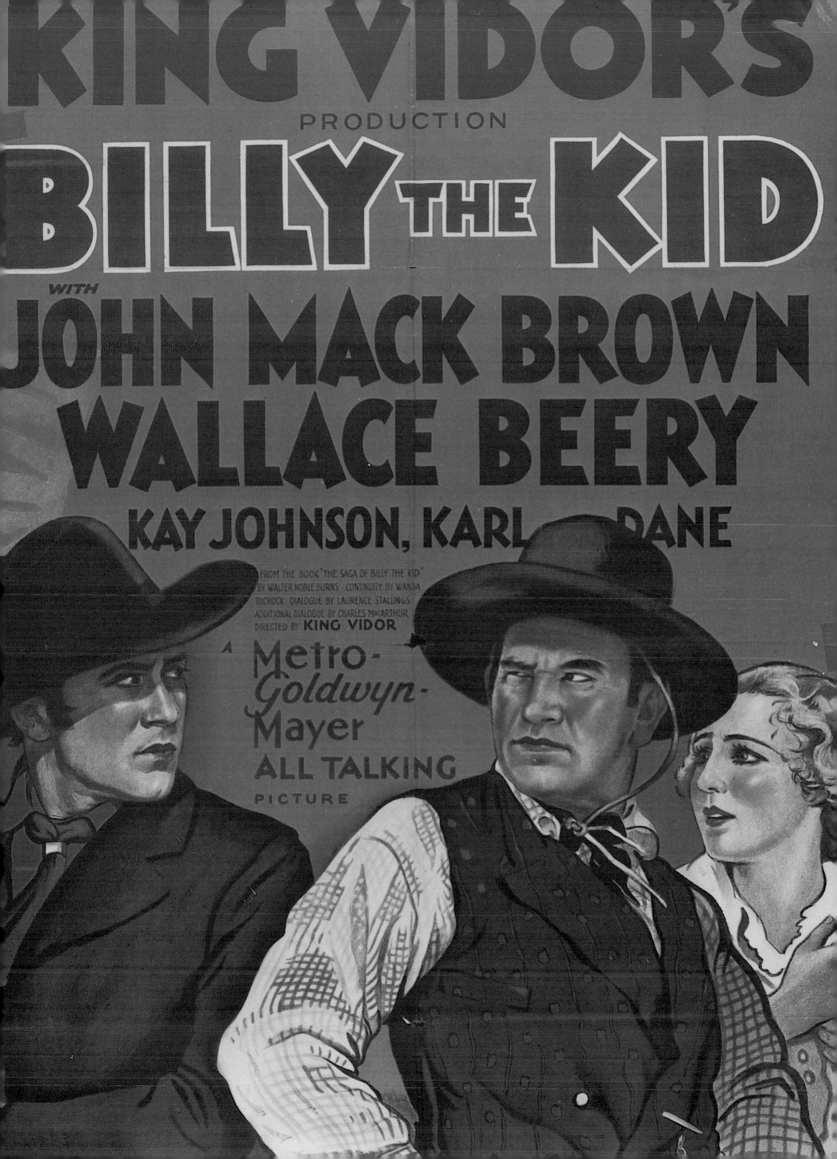

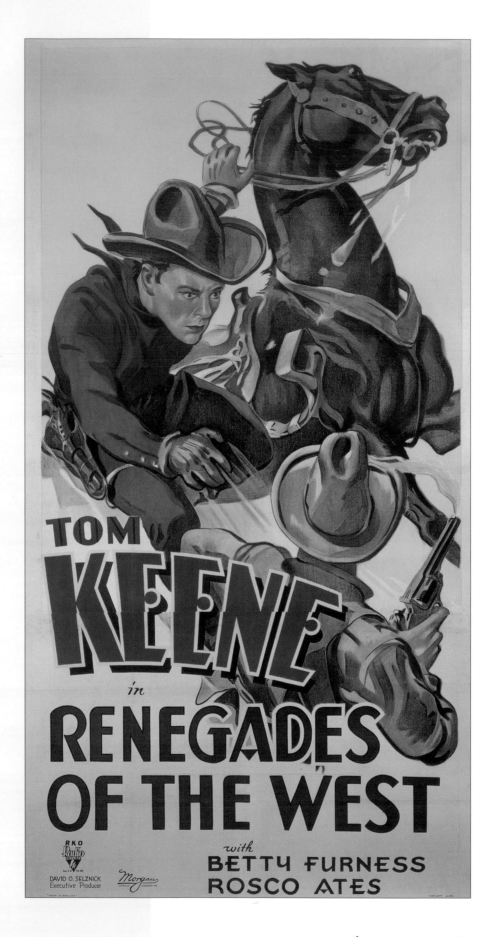

Renegades of the West
1932 RKO
A stoic cowboy (Tom Keene) goes under-
cover to hunt down the cattle thieves who
murdered his father. When he isn't plotting
murder, he raises a baby he found in the
desert.

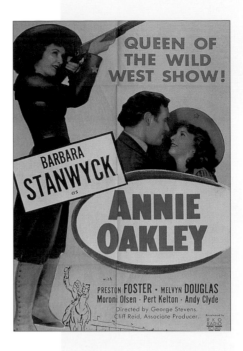

previous pages
The Fastest Guitar Alive
1967 MGM

Blazing ballads. An ex-Confederate spy (Roy Orbison) with a musical bent builds a gun into his guitar then teams up with singing dance-hall girls to escape with the Union's gold.

Billy the Kid
1930 MGM

Even his enemies didn't want to shoot him! In this early wide-screen talkie, the charismatic Kid (John Mack Brown) and his girl (Kay Johnson) are allowed to escape by Pat Garrett (Wallace Beery).

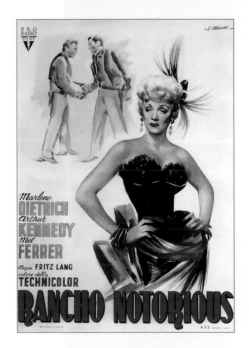

Annie Oakley
1935 RKO

Uncouth backwoods girl (Barbara Stanwyck) becomes a sharpshooter in Buffalo Bill's Wild West Show and falls hard for the show's other shooting star. Sitting Bull helps her win his heart.

Rancho Notorious
1952 RKO

A gentle rancher (Arthur Kennedy) turns brutal pursuing the man who murdered his fiancée. When he tracks the killer to a saloon queen's (Marlene Dietrich) hideout, they both get a shot at redemption.

The Man From Monterey
1933 Warner Bros.

An army captain (John Wayne) rides to Monterey to straighten out Mexican/American property rights. He foils the villain—who's out to swindle landowners—and rescues a Spanish damsel (Ruth Hall) in distress.

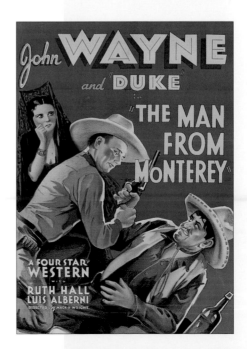

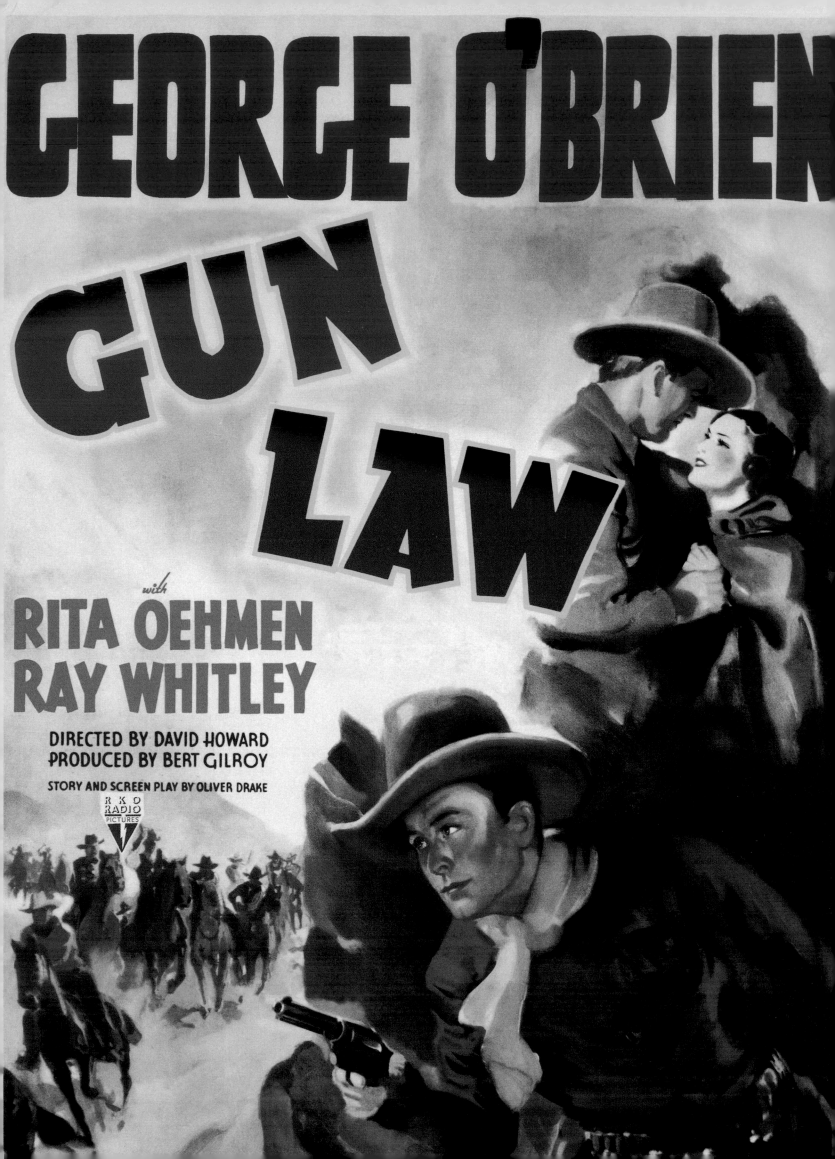

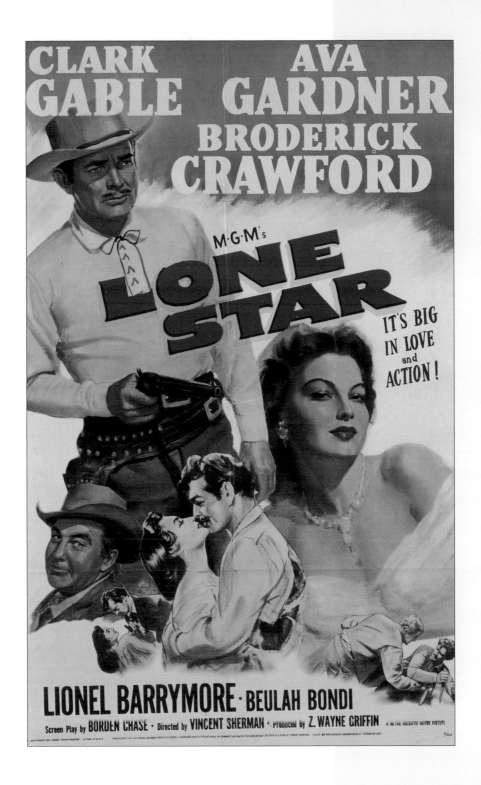

Gun Law
1938 RKO

A U.S. marshall (George O'Brien) goes
undercover as a notorious killer to bust a
gang of outlaws.

Lone Star
1952 MGM

A cattle baron (Clark Gable) who has a
way with women and words must bring
post–Alamo Texas into the Union. He meets
a fiery newspaper editor (Ava Gardner)
offering cleavage and help.

men in TIGHTS

The Orginal Action Heroes.

The whole world relishes a legend, m'lords and ladies. Particularly when that legend is brought to life by a handsome man with flashing eyes, rippling muscles, and—oh yes, a sword. Pirate, musketeer, knight, or knave, these dimpled swashbucklers won the hearts of men and women alike with elegant swordplay, cavalier villain rousting, and romantic damsel rescuing. Castle walls were made for scaling, chandeliers for swinging, and a duel to the death was one long, elegant pas de deux.

Early epic adventures loosely based on history (or classic novels) gave us action heroes who were both dashing and deadly. Posters celebrated this duality with key art devoting almost equal billing to the movie's romance and its action scenes. Angled titling and breathless prose were rendered in heraldic lettering against rich, opulent colors. Vignettes of smiling, leaping swordsmen and passionate embraces made clear the movie's intent: relatively bloodless battle, chivalrous love, the triumph of right, and flagons of mead all around.

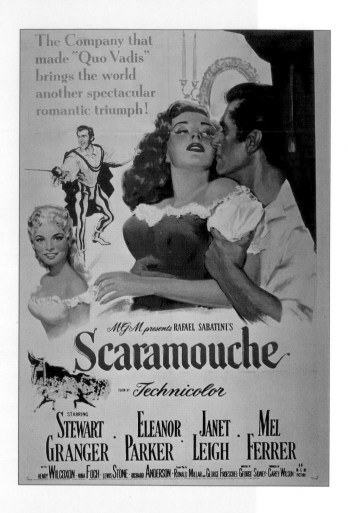

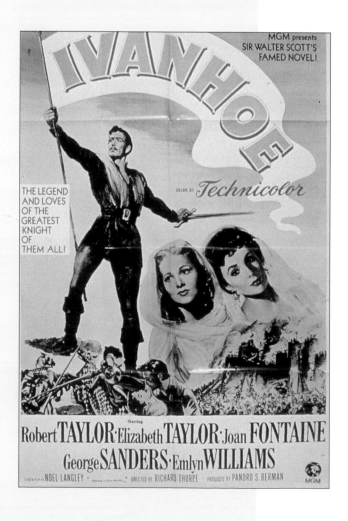

Scaramouche
1952 MGM

A nobleman's illegitimate son (Stewart Granger) vows to avenge his best friend's death in a duel, and masters fencing, so he can confront the swordsman (Mel Ferrer). Frilly French intrigue.

Ivanhoe
1952 MGM

Just home from the Crusades, Sir Wilfred of Ivanhoe (Robert Taylor) must ransom King Richard and restore him to England's throne. A beautiful woman (Elizabeth Taylor) and Robin Hood (Harold Warrender) help out.

The Prisoner of Zenda
1952 MGM

The evil Rupert's (James Mason) plot to steal Ruritania's throne is foiled when a doppelganger (Stewart Granger) subs for the kidnapped king (Stewart Granger). Luckily, the lookalike's handy with a sword.

following pages

Adventures of Don Juan
1948 Warner Bros.

The story of a legendary (Errol Flynn) swordsman—in every sense of the term—who conquered the boudoirs of Europe along with the heart of the queen of Spain (Viveca Lindfors).

The Adventures of Robin Hood
1938 Warner Bros.

England must be saved; there are rich to be robbed, and poor to be given to. Robin Hood (Errol Flynn) manages to do both, with help from Little John (Alan Hale) and Maid Marian (Olivia de Havilland).

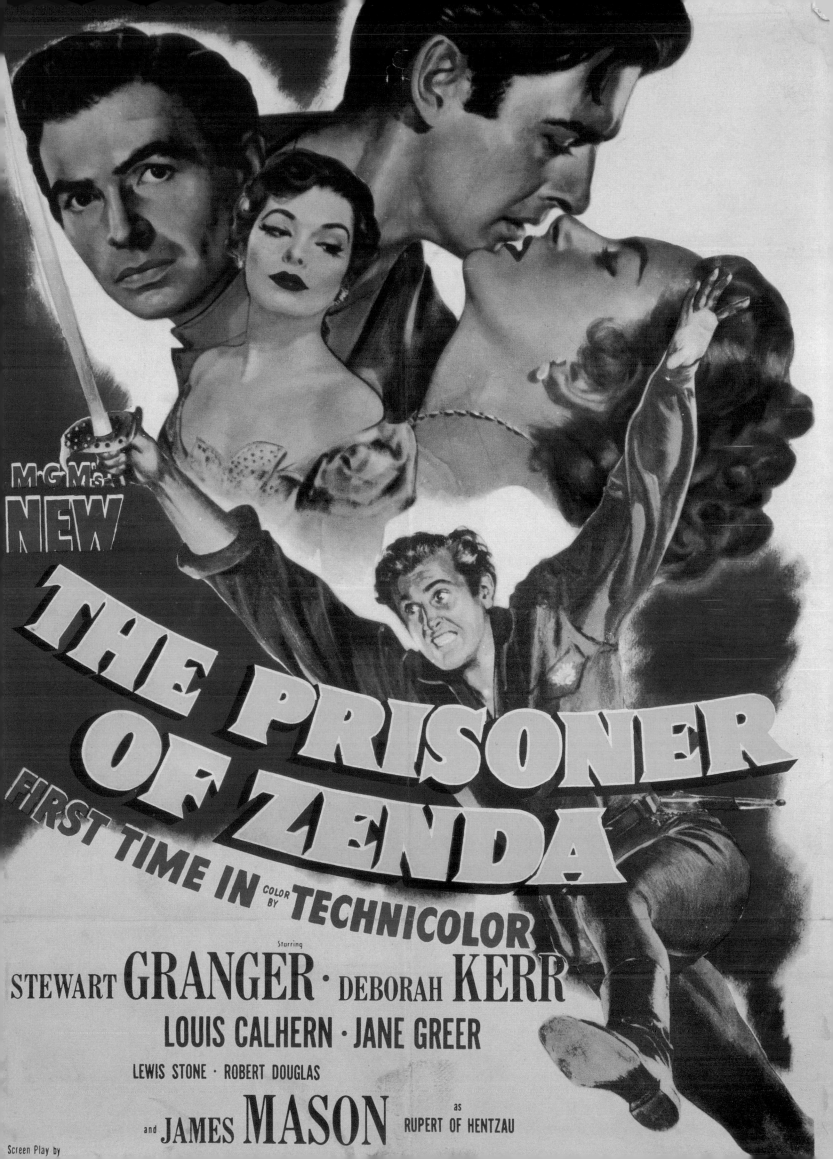

WARNER BROS. OPEN A NEW SCREEN ERA IN BREATHLESS ADVENTURE!

ADVENTURES OF DON JUAN

STARRING

ERROL FLYNN
VIVECA LINDFORS

IN COLOR BY
TECHNICOLOR

1949's BRAND NEW ADVENTURE SMASH!

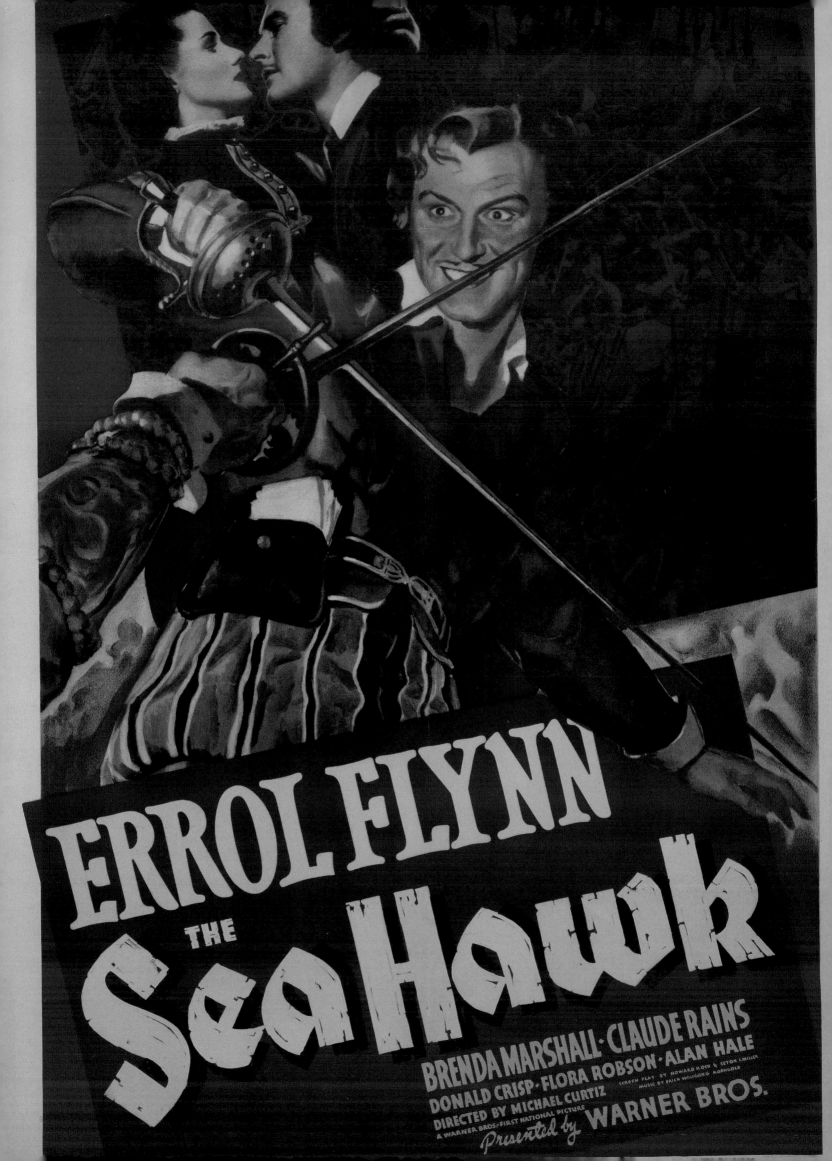

ERROL FLYNN

THE Sea Hawk

BRENDA MARSHALL · CLAUDE RAINS

DONALD CRISP · FLORA ROBSON · ALAN HALE

SCREEN PLAY BY HOWARD KOCH & SETON I. MILLER
MUSIC BY ERICH WOLFGANG KORNGOLD

DIRECTED BY MICHAEL CURTIZ

A WARNER BROS.-FIRST NATIONAL PICTURE

Presented by **WARNER BROS.**

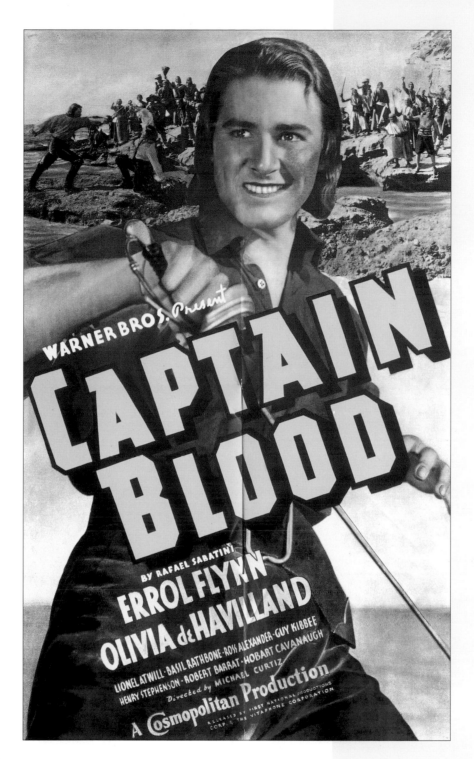

The Sea Hawk
1940 Warner Bros.

Phillip II of Spain (Montagu Love) casts
greedy eyes on England while clever
Elizabeth (Flora Robson) has her undercover
"Sea Hawk" (Errol Flynn) hard at work
plundering Spanish treasures to fund
England's defense.

Captain Blood
1935 Warner Bros.

A doctor's (Errol Flynn) charity gets him
in the soup, and he's sold into slavery in
Jamaica for it. He escapes his new owner
(Olivia de Havilland), becomes a pirate, and
their paths cross again.

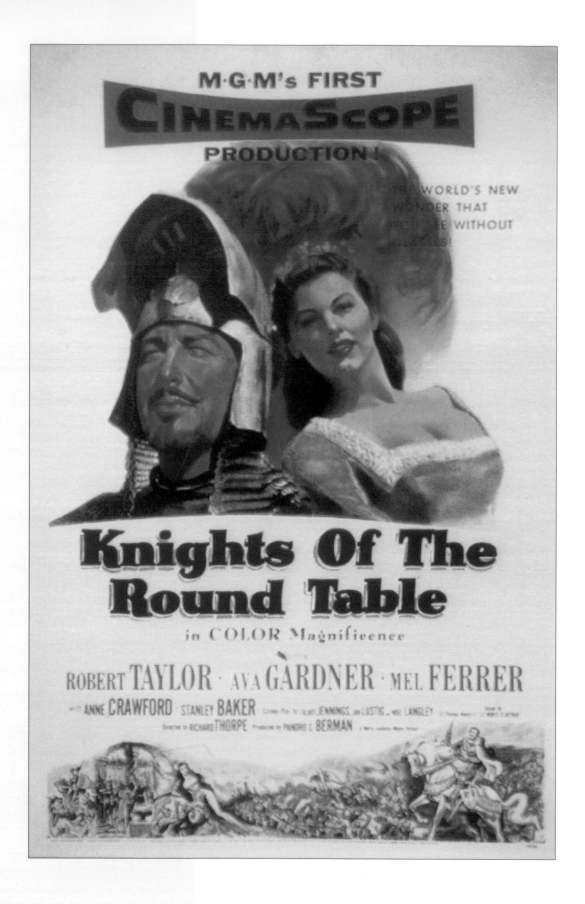

Knights of the Round Table
1953 MGM
They were both pledged to the death to King
Arthur (Mel Ferrer) and Camelot. So when
Queen Guinevere (Ava Gardner) loses her
heart to Sir Lancelot (Robert Taylor),
England hangs in the balance.

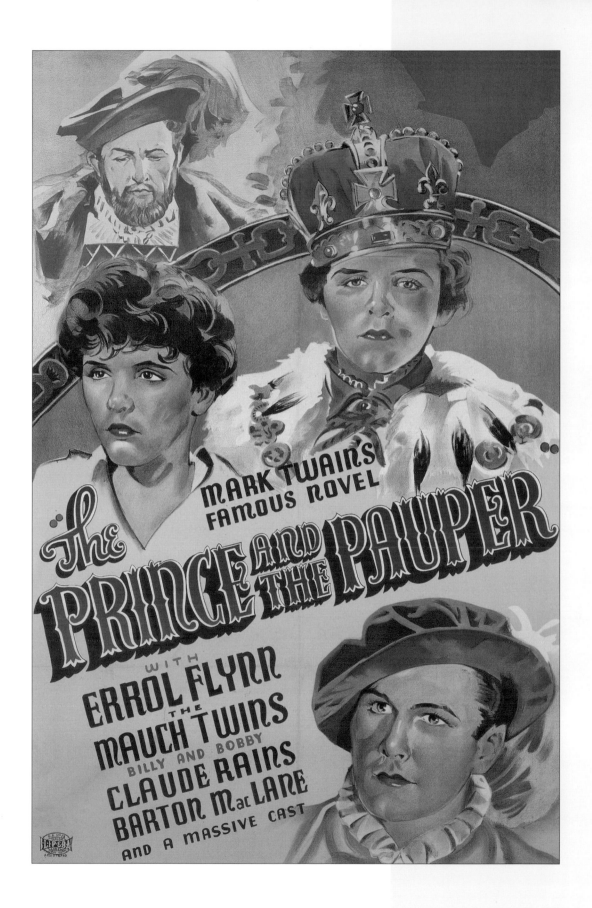

The Prince and the Pauper
1937 Warner Bros.
A boy prince (Bobby Mauch) trades places
with a look–alike pauper (Billy Mauch) and
finds sixteenth–century peasant life nothing
to smile about. Luckily, his bodyguard
(Errol Flynn) is feisty with a sword.

The Three Musketeers

FIRST TIME —
The Complete Romance... The Full Novel

Starring

LANA TURNER · GENE KELLY · JUNE ALLYSON

AS WICKED LADY DE WINTER · AS DEVIL MAY CARE D'ARTAGNAN · AS ILL-FATED CONSTANCE

VAN HEFLIN · ANGELA LANSBURY

AS DASHING ATHOS · AS ROMANTIC QUEEN ANNE

FRANK MORGAN · VINCENT PRICE · KEENAN WYNN · JOHN SUTTON

GIG YOUNG SCREEN PLAY BY ROBERT ARDREY DIRECTED BY GEORGE SIDNEY · PRODUCED BY PANDRO S. BERMAN
A METRO-GOLDWYN-MAYER PICTURE

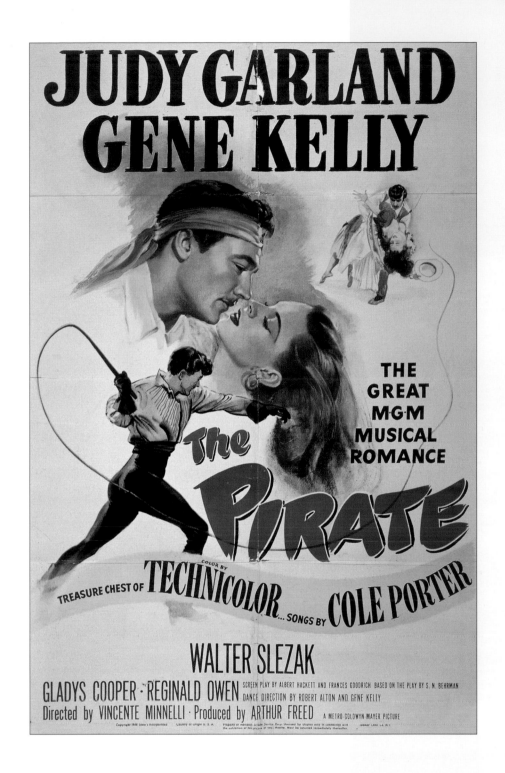

The Three Musketeers
1948 MGM

A dancing D'Artagnan (Gene Kelly) swash-
buckles his way into the famous French cav-
aliers, where the protection of king, queen,
and beauty is their raison d'être and "all for
one, one for all" is their motto.

The Pirate
1948 MGM

A Spanish lady (Judy Garland) fantasizes
about a legendary pirate, so a street per-
former (Gene Kelly) masquerades as that
pirate to impress her. It works. Eventually,
they don red noses and sing "Be a Clown."

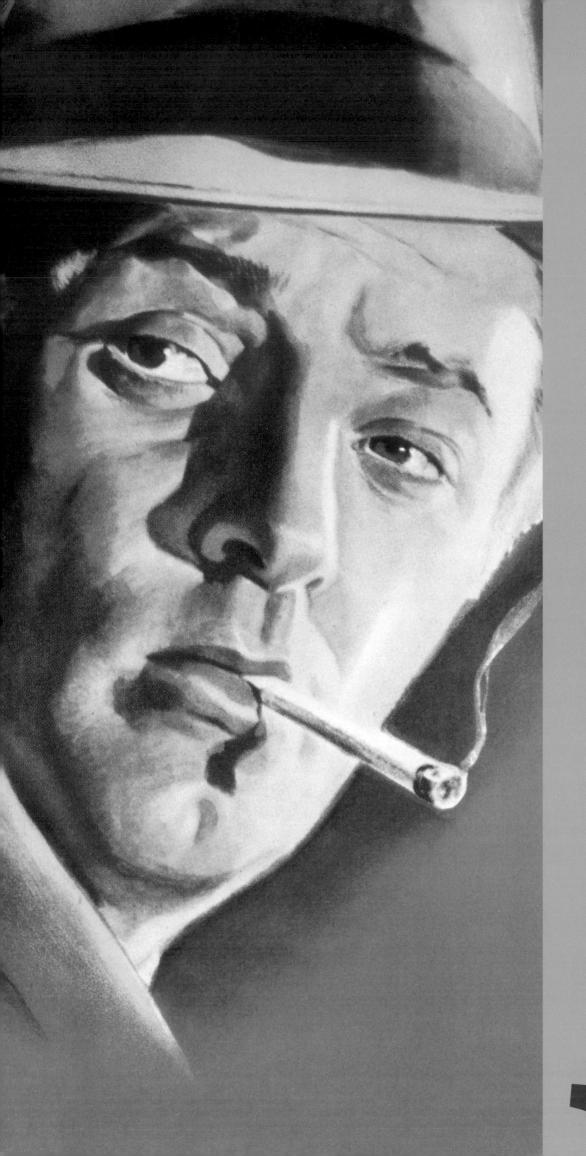

tough GUYS

Crime and Punishers.

They exploded onto the screen as gangsters, ruthless men who spun booze into gold. Only a few moralizing years later, they morphed into G-men who were just as fearless fighting for the law as they had been against it. But good or bad, Tough Guys became more complex over the years. They were hard men, yes, but they were not hard-hearted. Some of their struggles were even internal. Whatever else they were, they were real: men's men women loved, other men respected, and everybody feared, just a little.

You can find a Tough Guy in almost any genre, but their posters will often share certain traits. Illustrations or color palettes stylized to the times—art deco for the early thirties, portraiture in the late forties and fifties, stark black-and-white or op art for the sixties. Key art of the protagonist (you can't always call him a hero) is often alienated, disconnected from the ever-present plot vignettes. And whether it is literal or figurative, some element in the poster will be smoking: a gun, a cigarette, or a woman.

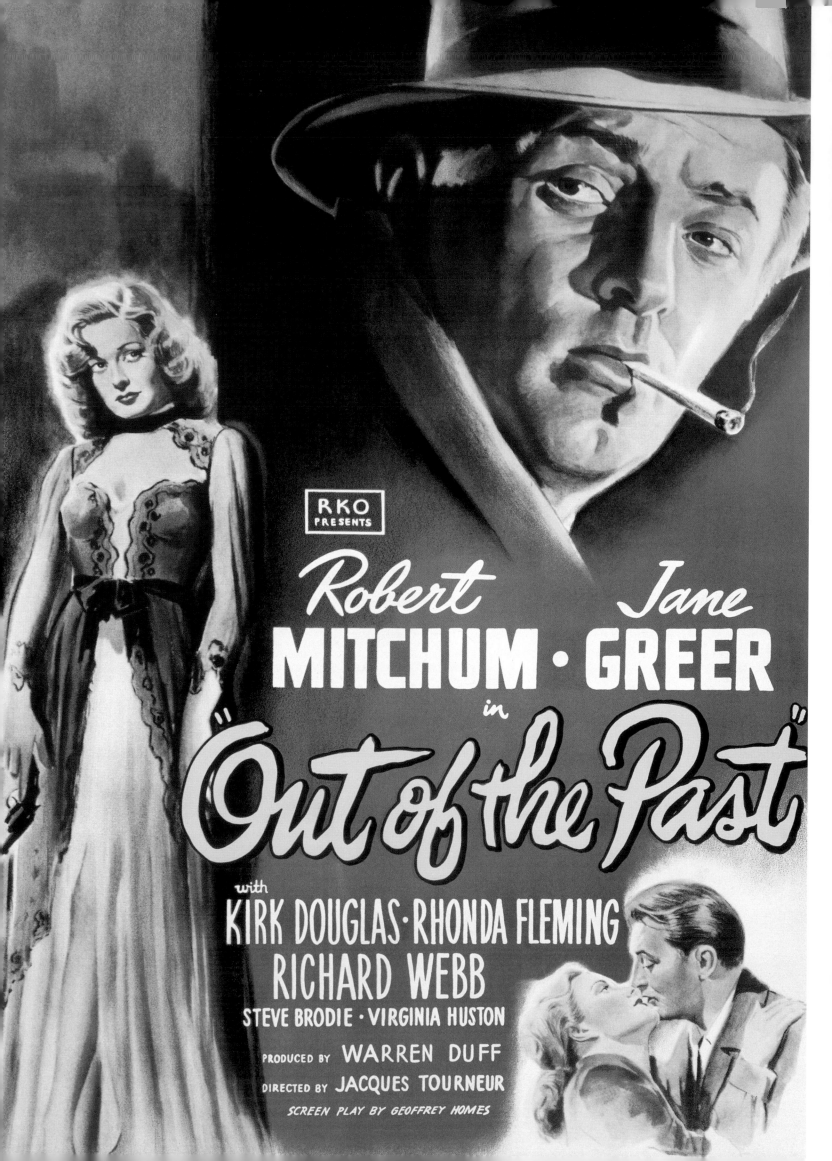

Out of the Past
1947 RKO

When his sordid past comes back to haunt him, a hard-nosed ex-detective (Robert Mitchum) decides to take down the gambling boss (Kirk Douglas) and the witchy woman (Jane Greer) doing the haunting.

A Streetcar Named Desire
1951 Warner Bros.

With wife Stella (Kim Hunter) pregnant and neurotic sister-in-law Blanche (Vivien Leigh) having the vapors, it's all red-blooded Stanley Kowalski (Marlon Brando) can do to keep his shirt on.

The Maltese Falcon
1941 Warner Bros.

Sam Spade's (Humphrey Bogart) partner is the first, but not the last, to die when a double-dealing beauty (Mary Astor) and "The Fat Man" (Sydney Greenstreet) hunt for a legendary jewel-encrusted falcon.

following pages

Bullitt
1968 Warner Bros.

When his government witness is mortally wounded, a lone-wolf detective (Steve McQueen) baits the killers by pretending the informer is still alive—inspiring the car chase to end all car chases.

Cool Hand Luke
1967 Warner Bros.

A hard-headed loner (Paul Newman) goes to a brutal chain gang on trumped-up charges and has a "failure to communicate" with the Boss. When the guards can't break him, they kill him.

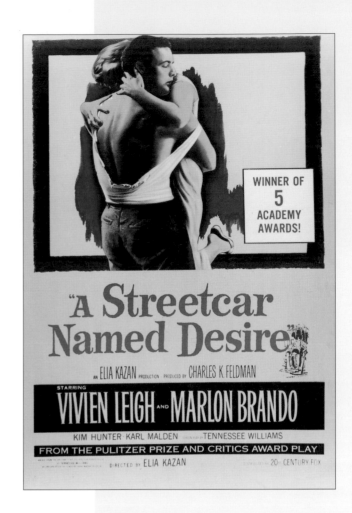

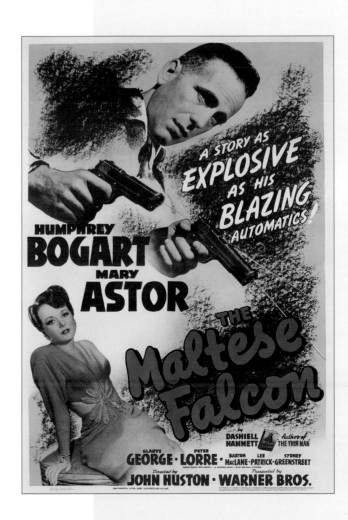

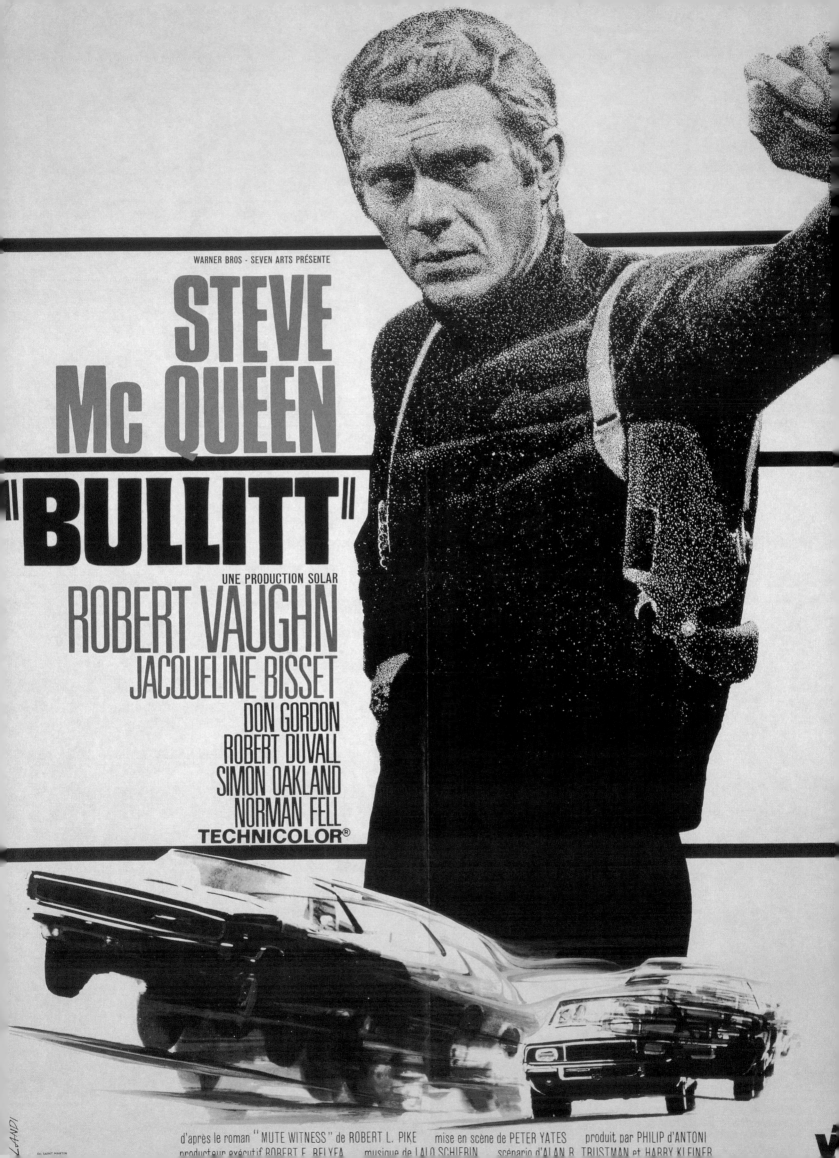

WARNER BROS - SEVEN ARTS PRÉSENTE

STEVE McQUEEN

"BULLITT"

UNE PRODUCTION SOLAR

ROBERT VAUGHN
JACQUELINE BISSET
DON GORDON
ROBERT DUVALL
SIMON OAKLAND
NORMAN FELL
TECHNICOLOR®

d'après le roman "MUTE WITNESS" de ROBERT L. PIKE mise en scène de PETER YATES produit par PHILIP d'ANTONI

producteur exécutif ROBERT E. RELYEA musique de LALO SCHIFRIN scénario d'ALAN R. TRUSTMAN et HARRY KLEINER

The man...and the motion picture that simply do not conform.

PAUL NEWMAN
COOL HAND LUKE

CO-STARRING
GEORGE KENNEDY · J. D. CANNON ROBERT DRIVAS · LOU ANTONIO JO VAN FLEET STUART ROSENBERG · GORDON CARROLL
 STROTHER MARTIN and DIRECTED BY PRODUCED BY
SCREENPLAY BY
DONN PEARCE and FRANK R. PIERSON Music by TECHNICOLOR® PANAVISION FROM WARNER BROS.-SEVEN ARTS
 Lalo Schifrin

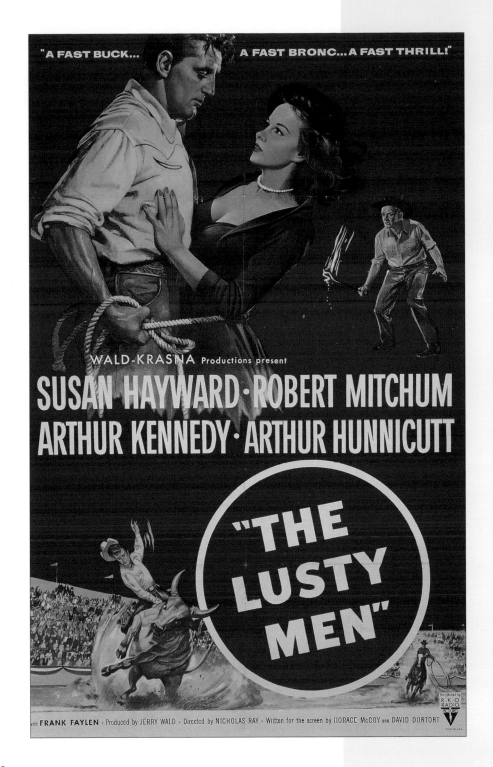

Manhattan Melodrama (En Manhattan-Melodram)
Swedish
1934 MGM
Two tough-as-nails orphans grow up
together. One (Clark Gable) takes to a life
of crime and the other (William Powell) to
public service, but they both take to the
same beautiful woman (Myrna Loy).

The Lusty Men
1952 RKO
A beat-up rodeo king (Robert Mitchum)
takes one fall too many and agrees to train a
greenhorn (Arthur Kennedy) for the money—
and because the man's wife (Susan Hayward) is
a cowboy's sweaty dream come true.

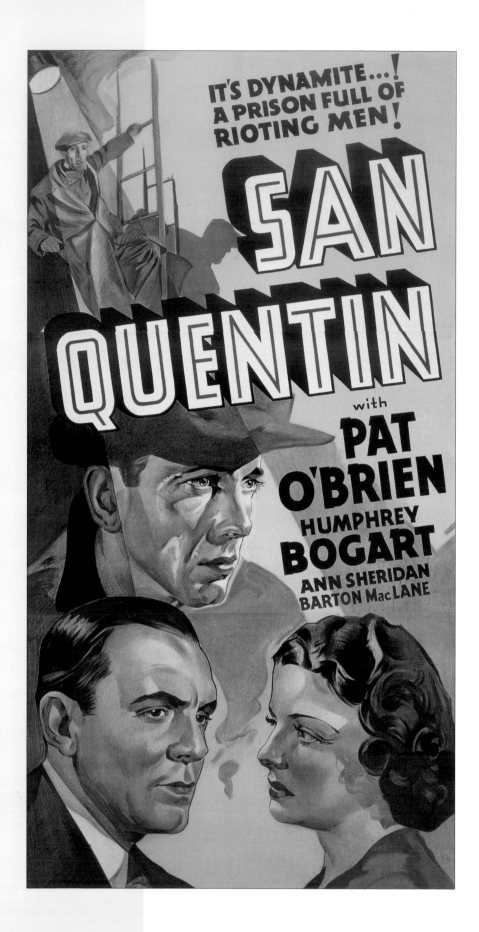

San Quentin
1937 Warner Bros.
The new warden (Pat O'Brien) wants to clean
up the big house even before he falls in love
with an inmate's (Humphrey Bogart) sister
(Ann Sheridan). When his reforms start to pay
off, the old-school guards get even.

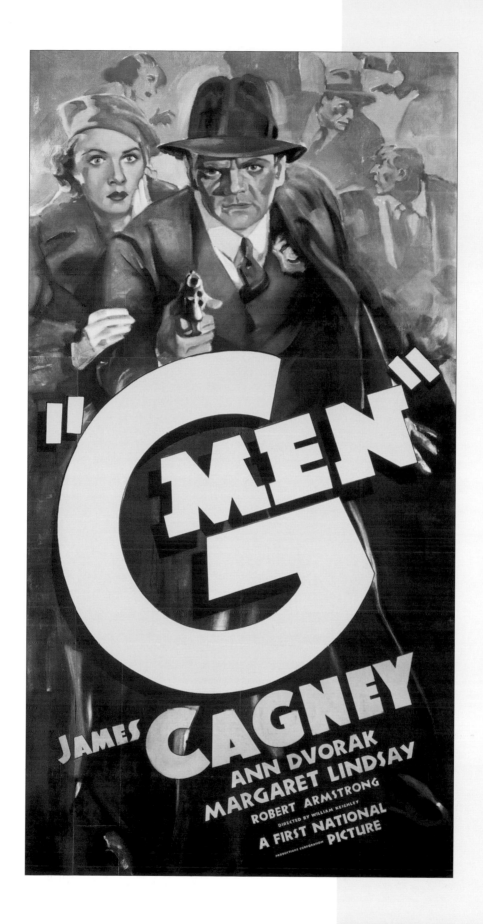

G-Men
1935 Warner Bros.

A fearless lawyer turned FBI agent (James
Cagney) swears vengeance on old mob pals
for murdering an unarmed fellow agent
then has to dodge enemies in his own ranks.

JAMES DEAN
NATALIE WOOD
SAL MINEO

in Warner Bros.

"REBEL WITHOUT A CAUSE"

in CINEMASCOPE
AND WARNERCOLOR

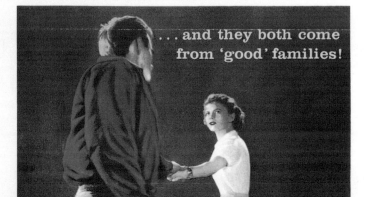

...and they both come from 'good' families!

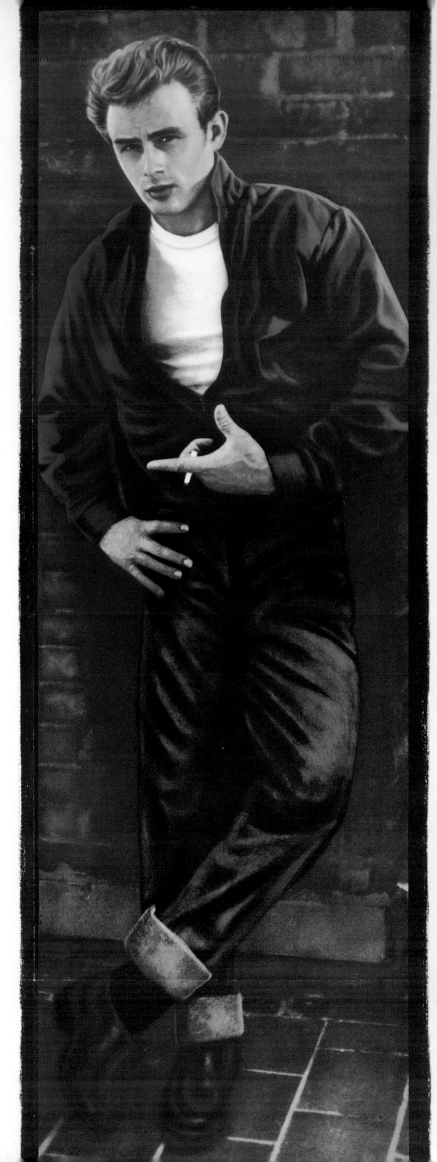

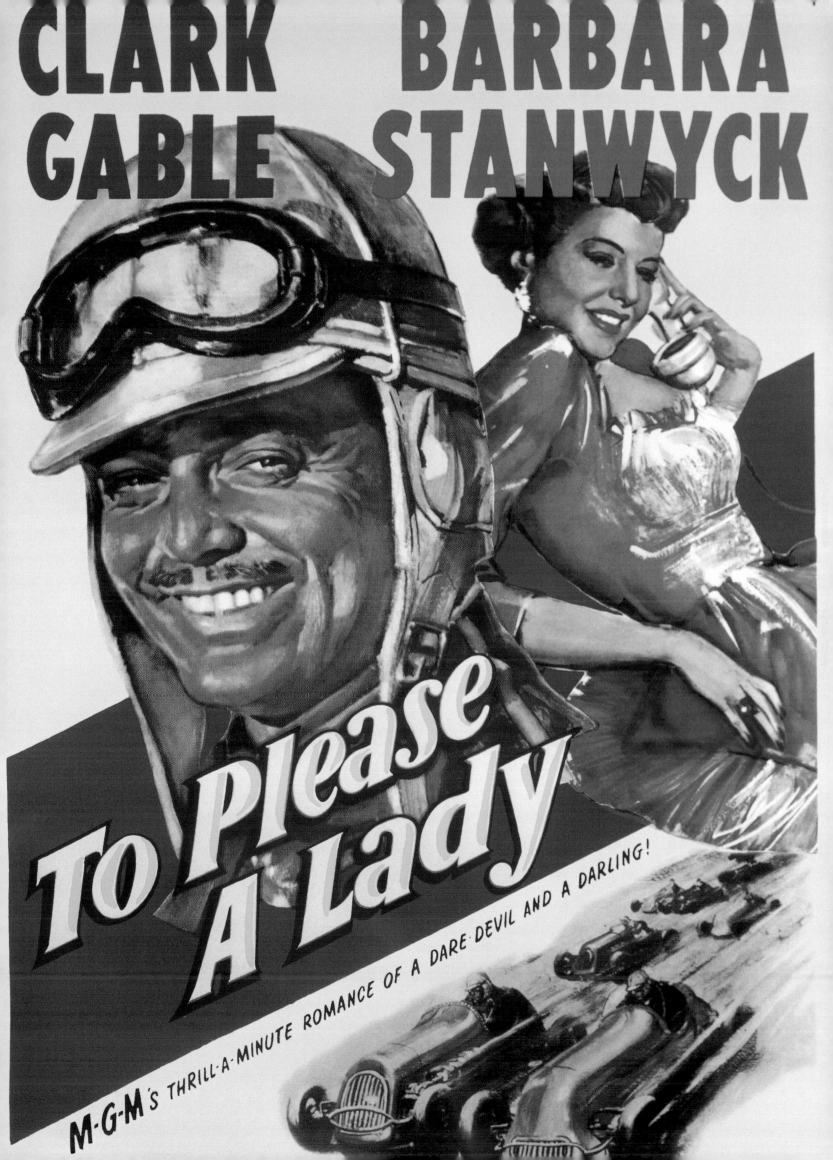

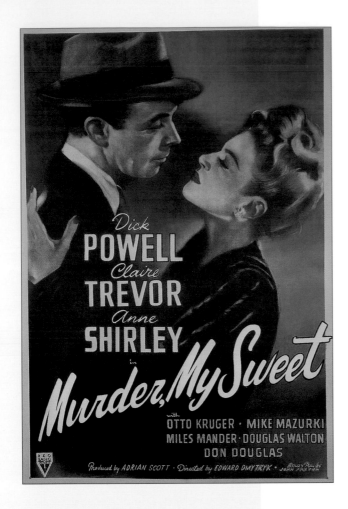

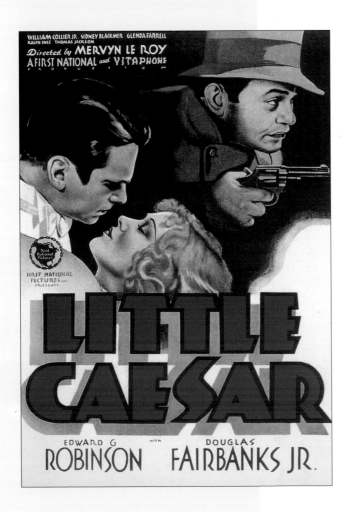

previous pages
Rebel Without a Cause
1955 Warner Bros.
An angry, alienated teenager (James Dean) struggling to find himself kicks off a fatal chain of events when he asks the girlfriend (Natalie Wood) of a local hot-rodder for a date.

To Please a Lady
1950 MGM
Racing, romance, and tragedy take a few laps around the track when a notorious race-car driver (Clark Gable) runs into the slinky but hard-nosed reporter (Barbara Stanwyck) whose columns have had him barred from the racing circuit.

Murder, My Sweet
1944 RKO
Dark, intense, violent—and brilliant. Hard-boiled P.I. Philip Marlowe (Dick Powell) searches for a cretinous thug's (Mike Mazurki) missing girlfriend and finds a nightmare of jewel thieves, hypodermic needles, and murder.

Little Caesar
1931 Warner Bros.
The only thing that mattered to Rico (Edward G. Robinson) was power—and he didn't care who he murdered to get it. This film chronicling the bloody rise and fall of a Capone-like killer launched the genre.

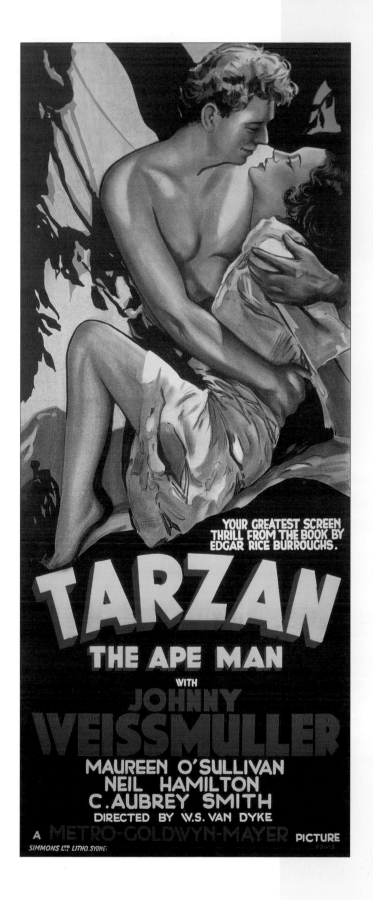

Tarzan the Ape Man
1932 MGM

Tarzan (Johnny Weissmuller) kills lions with
his bare hands, wrestles alligators, and com-
mands elephants—all to save the life of Jane
(Maureen O'Sullivan), the woman he kidnapped
out of curiosity but quickly came to love.

weird & WEIRDER

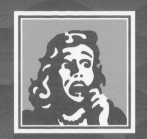

The Dark Side Rules.

Fear is not the same thing as gore. It is much worse. Witness these thinking person's horror films. They are the movies you'll remember when you least wish to do so. Here in this world of suggested shadow and literate fear, nothing is what it seems. Here the cursed cozy up to the damned against the demented. All manner of things will go bump in this dark night, starting with your heart. So come. Open the door. They are waiting. And they are not alone.

Indeed, horror-movie posters need never fear being alone. They are among the most collectible of posters, partly because of how succinctly they reflect the night-mares of their day, from the seductive she-creatures of the thirties to the atomic anomalies of the fifties. The challenge was great: evoke fear itself—not necessarily the source of it. Title lettering trembled across festering color palettes. Vignettes and portraits were often shadowy, vague and distorted. Except for the eyes. Whether they screamed or stared, they crawled right off the page and into your dreams.

The Walking Dead
1936 Warner Bros.

A gentle ex-convict (Boris Karloff) is framed for murder, wrongly executed, and then brought back to life when his innocence is proven. Like any self-respecting living dead, he seeks revenge on those who betrayed him.

The Haunting
1963 MGM

A professor (Richard Johnson) studying ESP invites "sensitive" guests to an evil New England mansion with a mind of its own. The house invites lonely, fragile Eleanor (Julie Harris) to stay forever.

The Green Slime
1968 MGM

A spaceship exploring deep space does battle with an asteroid headed right toward planet Earth. In the process, the crew (Richard Jaeckel/Robert Horton) picks up some nasty green slime that turns into one-eyed tentacled monsters.

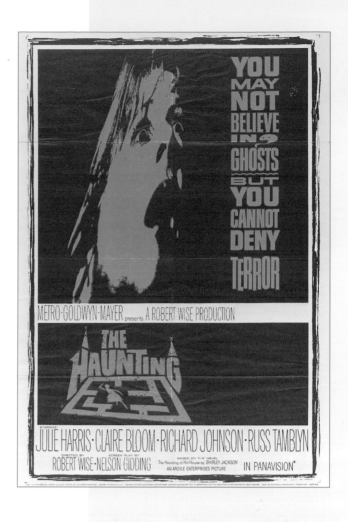

following pages

I Walked with a Zombie
1943 RKO

Salacious title for the spellbinding story of a young nurse (Frances Dee) who goes to Haiti and gets caught up in a dark love triangle revolving around her boss's (Tom Conway) mysteriously catatonic wife (Christine Gordon).

Cat People
1942 RKO

A beautiful bride (Simone Simon) believes an ancient legend that says if she makes love to her husband (Kent Smith), she will become a panther and claw him to death. She's worse when she gets jealous.

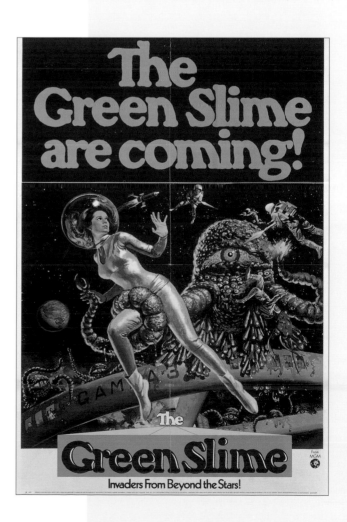

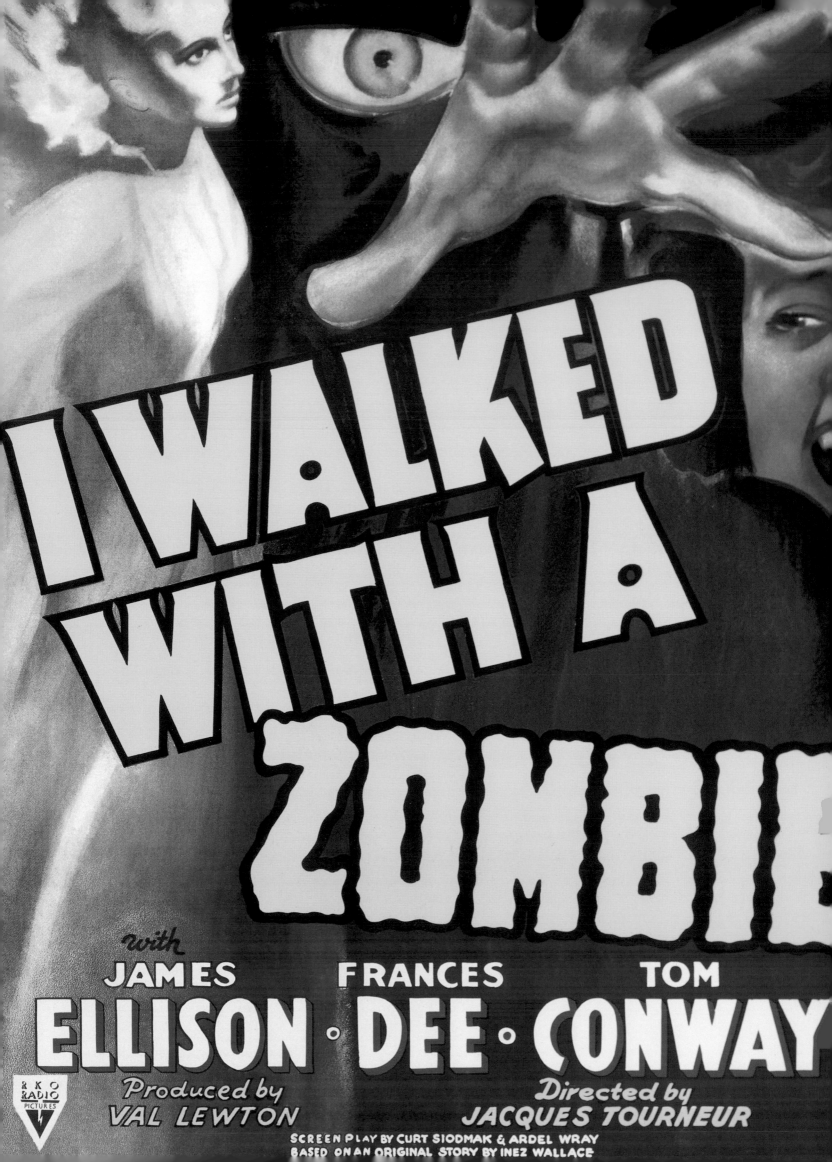

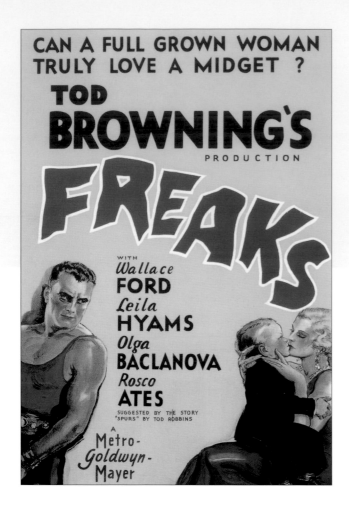

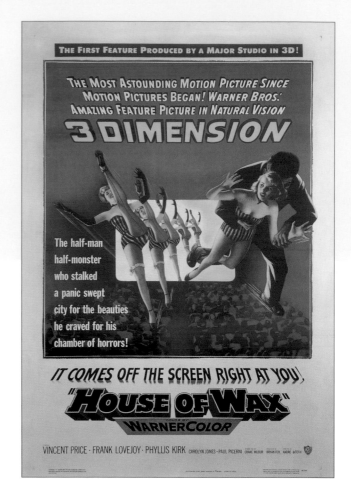

Freaks
1932 MGM

An avaricious trapeze star (Olga Baclanova) marries a midget (Harry Earles) for his money, then scorns his freak friends. She pays for her sins with her beauty and winds up queen of the freak show.

House of Wax
1953 Warner Bros.

After his life's work is destroyed, a disfigured wax sculptor (Vincent Price) begins anew with the help of an assistant (Charles Bronson). Their sculptures are so lifelike, they seem like flesh and blood—literally.

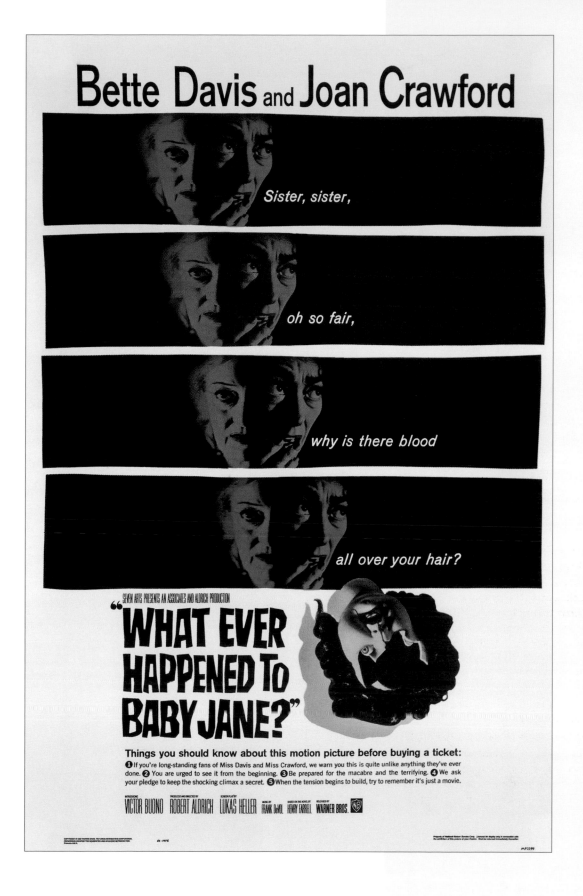

What Ever Happened to Baby Jane?
1962 Warner Bros.
Yum, roast rat for dinner. Two sisters, both
faded Hollywood stars, play demented cat
(Bette Davis) and crippled mouse (Joan
Crawford) in a crumbling mansion filled
with rotting memorabilia from one sister's
child-star days.

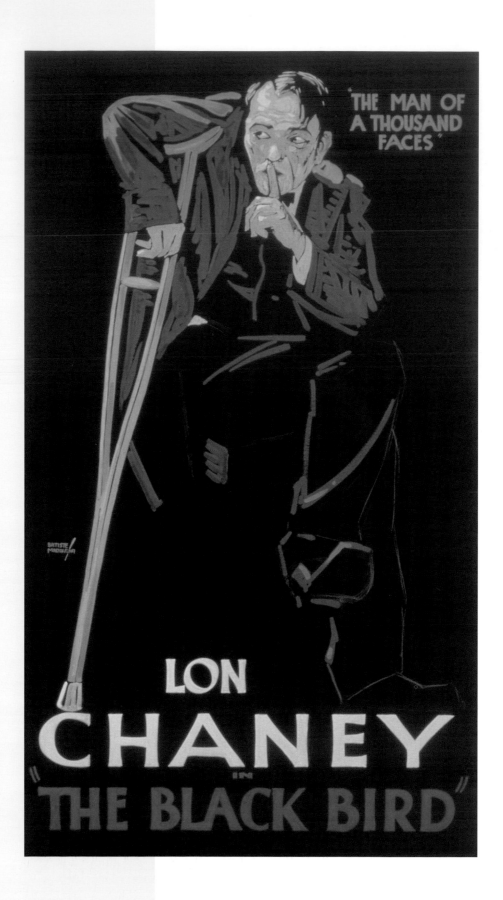

The Black Bird
1926 MGM
A master criminal (Lon Chaney) disguises
himself as a crippled missionary to escape
the long arm of the law. A higher law claims
him when he realizes his disguise has
become permanent.

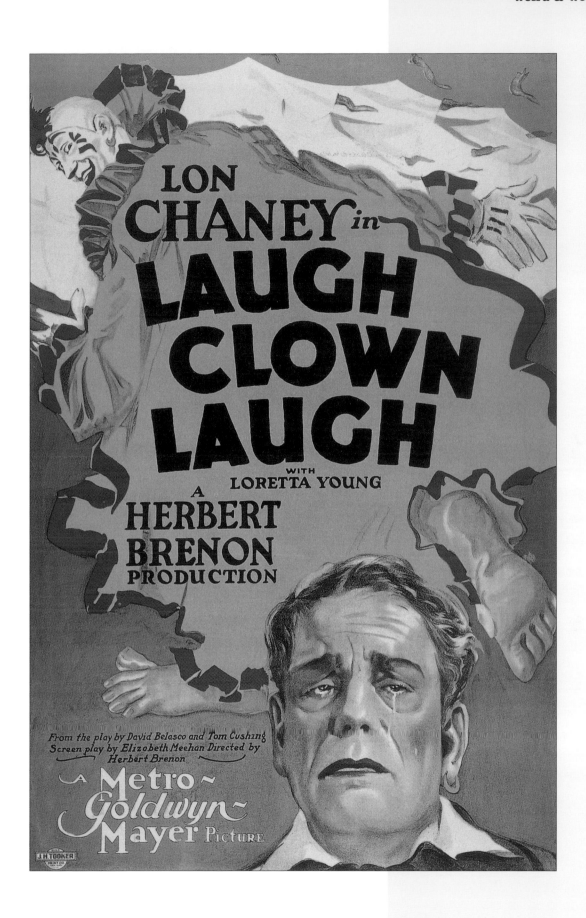

Laugh, Clown, Laugh
1928 MGM
An aging circus performer (Lon Chaney) confesses his love for the girl (Loretta Young) he raised since childhood. When he realizes she feels bound to him by duty and not love, he orchestrates his own death.

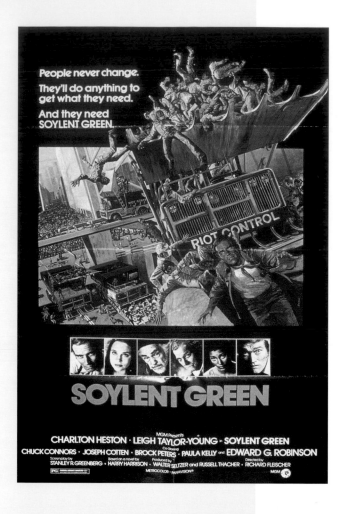

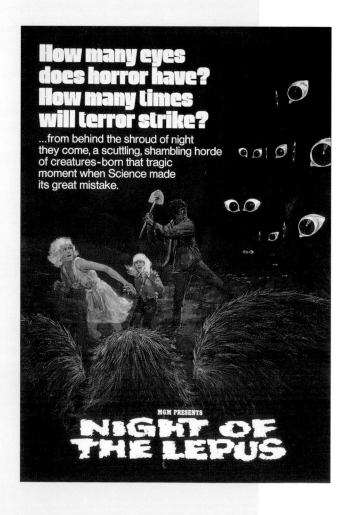

Soylent Green
1973 MGM

In twenty-first-century New York, there is no more real food, and people survive on wafers of Soylent Green until they elect to die. Then a detective (Charlton Heston) finds out what they're really made of.

Night of the Lepus
1972 MGM

When bunnies eat him out of grass and home, a rancher (Rory Calhoun) asks two scientists (Stuart Whitman/Janet Leigh) to stop them with science. Naturally, Mother Nature fights back with giant man-eating bunnies.

The Thing from Another World
1951 RKO

When a spaceship crashes into a polar expedition site, an air force captain (Kenneth Tobey) and a scientist (Robert Cornthwaite) disagree on what to do with the frozen alien (James Arness) who views them as dinner.

following pages

Them!
1954 Warner Bros.

Atomic ants come marching two by two, eating every man, woman, and trailer in New Mexico, until a state trooper (James Whitmore), an FBI man (James Arness), and a scientist (Joan Weldon) track the queen to her lair.

The Invisible Boy
1957 MGM

The young son (Richard Eyer) of a scientist (Philip Abbott) grows up closer to his robot (Robby) than to his real father. Then his father invents a supercomputer that threatens Robby's "life."

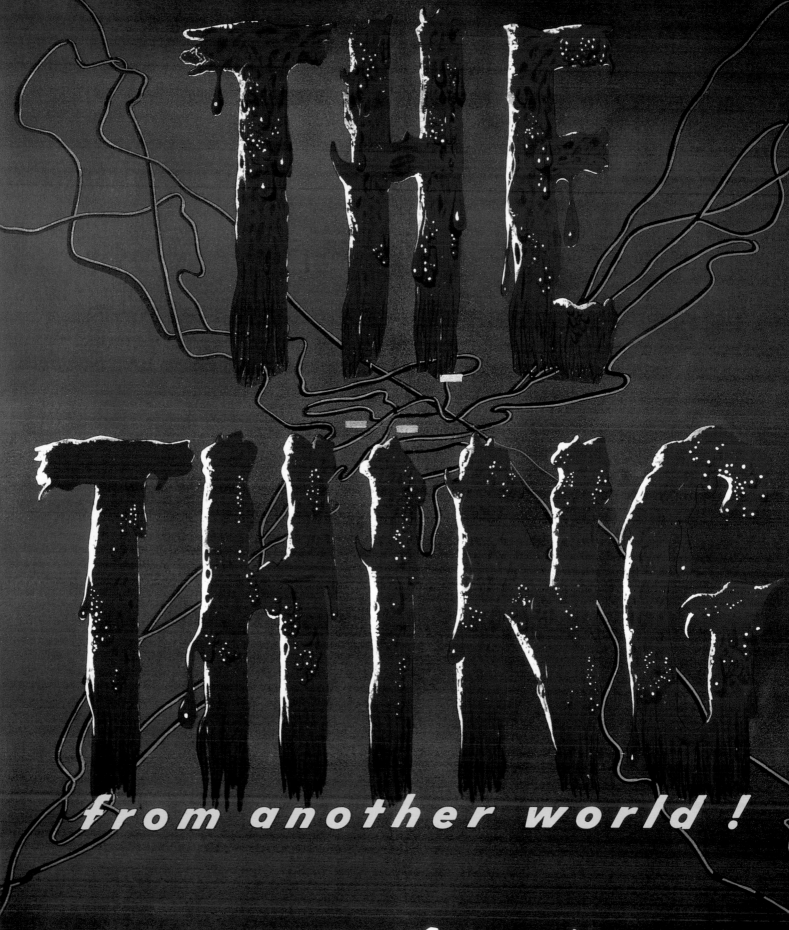

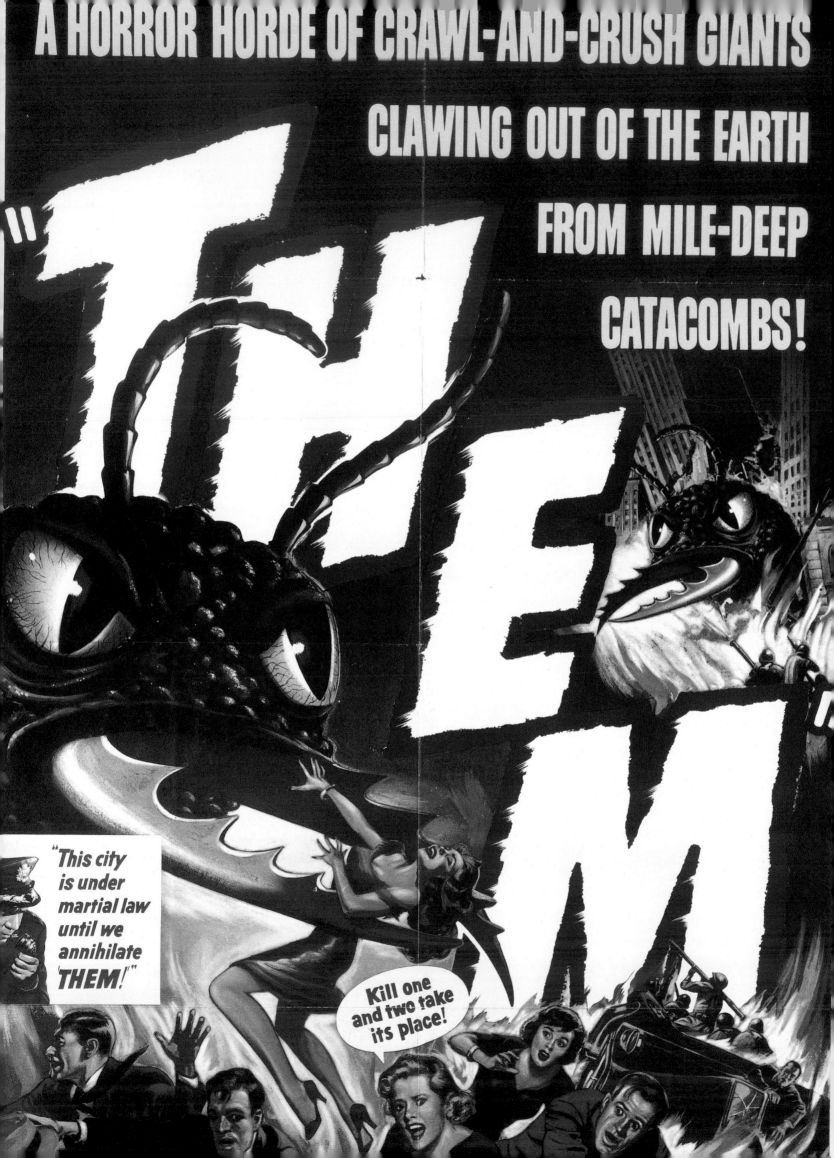

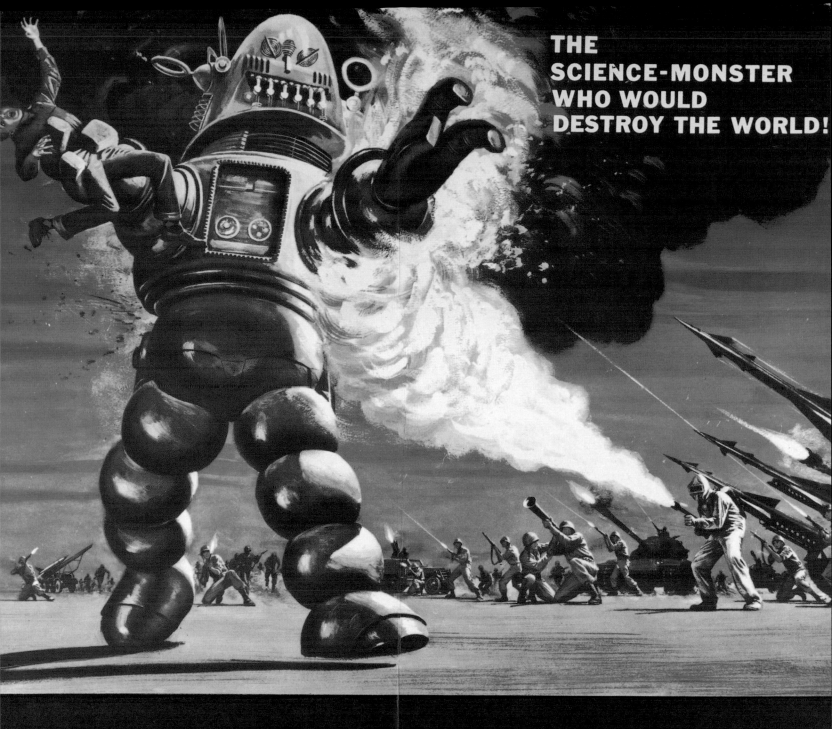

THE SCIENCE-MONSTER WHO WOULD DESTROY THE WORLD!

M·G·M PRESENTS The Invisible Boy

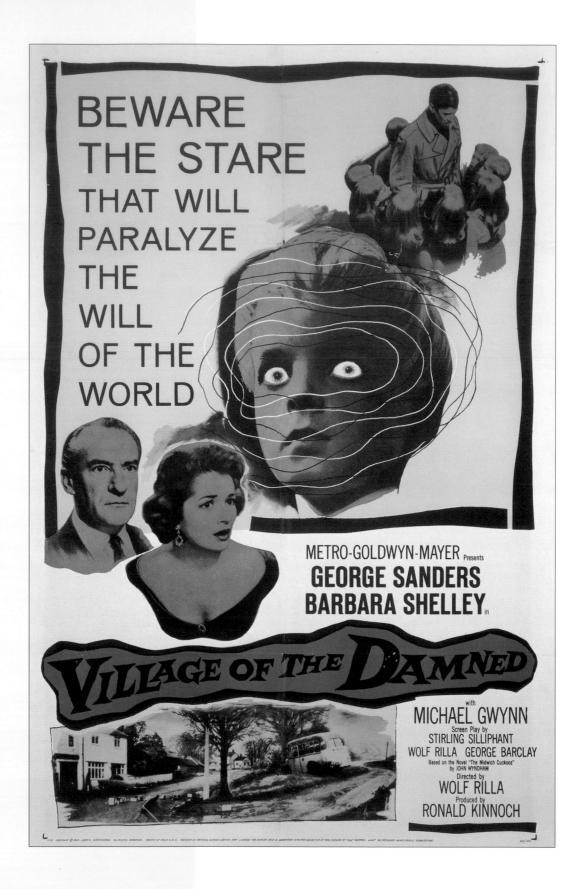

Village of the Damned
1960 MGM
An entire English village goes to sleep one night and a dozen women wake up impregnated by aliens. The towheaded, telekinetic little monsters will control the Earth unless their teacher (George Sanders) can stop them.

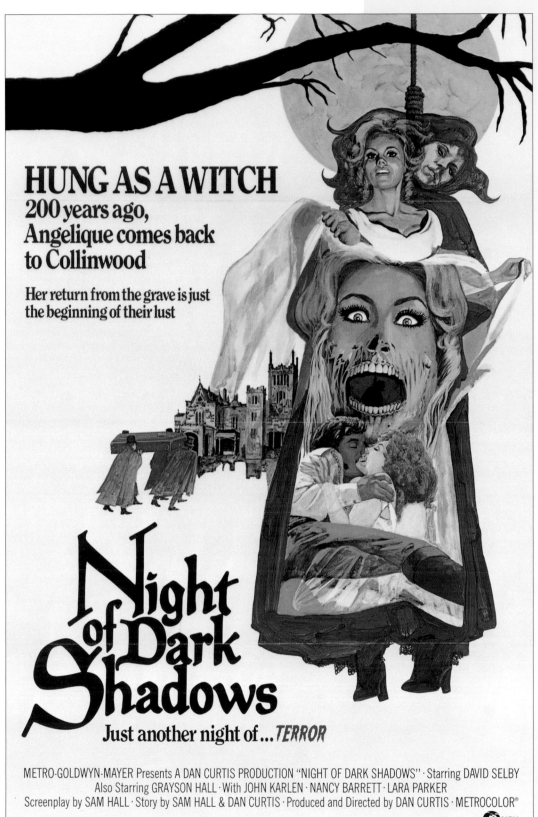

Night of Dark Shadows
1971 MGM
The last surviving Collins (David Selby)
inherits the 150-year-old family mansion
and, along with it, the family curse. Soon,
his taste for blood makes him see his bride
(Kate Jackson) in a whole new light.

INDEX BY TITLE

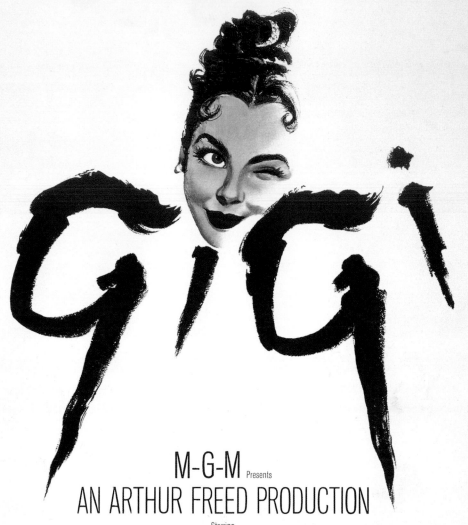

THE FIRST LERNER-LOEWE MUSICAL
SINCE "MY FAIR LADY"

M-G-M Presents
AN ARTHUR FREED PRODUCTION
Starring
LESLIE CARON
MAURICE CHEVALIER · LOUIS JOURDAN
HERMIONE GINGOLD · EVA GABOR · JACQUES BERGERAC · ISABEL JEANS
Screen Play and Lyrics by ALAN JAY LERNER · Music by FREDERICK LOEWE · Based on the Novel by COLETTE
Costumes, Scenery & Production Design by CECIL BEATON · In CinemaScope And METROCOLOR · Directed by VINCENTE MINNELLI

1958 MGM

A gangly, girlish waif (Leslie Caron) is transformed into a glamorous Parisian woman by her worldly grandmother (Hermione Gingold). When the city's most eligible bachelor (Louis Jourdan) proposes romance, but not marriage, she holds out for the fairy tale.